IMAGES
of America
EARLY MILL VALLEY

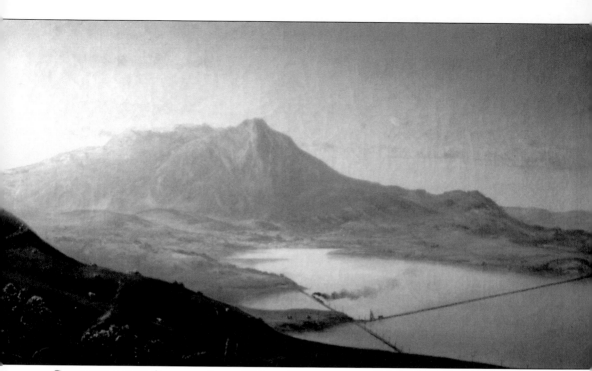

GATEWAY TO THE *SLEEPING LADY*. This majestic painting of Mount Tamalpais by artist Norton Bush (1834–1894) captures the setting for this story and the dominant role Mill Valley's "Sleeping Lady" mountain played in the evolution of the town. For nine years, North Pacific Coast Railroad trains ran over a 4,000-foot-long wooden trestle across Richardson Bay, from Sausalito to Strawberry and along the peninsula's east side. By the time this was painted, after 1884, the trestle had been abandoned. The new train tracks shown here run straight from the Sausalito terminal to Waldo Point. (Courtesy California Historical Society.)

ON THE COVER: This is downtown Mill Valley as it looked to those arriving by train at the depot from about 1905 to 1910. Miller Avenue, still unpaved, is on the left, and the train station is on the right. Against the backdrop of Mount Tamalpais, the "Steamboat House" overlooks the town from its sparsely wooded hilltop. (Courtesy MVLHR.)

IMAGES
of America

EARLY MILL VALLEY

Claudine Chalmers

ARCADIA
PUBLISHING

Published by Arcadia Publishing
Charleston, South Carolina

Printed in the United States of America

Library of Congress Catalog Card Number: 2005929125

For all general information contact Arcadia Publishing at:
Telephone 843-853-2070
Fax 843-853-0044
E-mail sales@arcadiapublishing.com
For customer service and orders:
Toll-Free 1-888-313-2665

Visit us on the Internet at www.arcadiapublishing.com

To Benoit, Kenneth, Zack, and Abigail, our Mill Valley kids. From Marin General to Tam High and the world, we hope they never forget the loving mountain that watched them grow.

SUKI HILL. Professional photographer Hill has hunted and captured Mill Valley images for over 40 years. Her permanent exhibit at the city's library juxtaposes her photographs of the community from the 1960s to today with photographs from her vintage collection, illuminating the changing face of contemporary life and its connection to generations past. Mill Valley's photographer extraordinaire contributed both vintage views and her own images to this work.

CONTENTS

ACKNOWLEDGMENTS

Collector and historian Jim Staley stands out among the many who contributed their expertise to this book. His purchase in 1994, of two albums containing about 500 Marin County postcards, led to a dedicated quest for more, and his collection has now grown to more than 3,500 cards. With typical generosity, he made these, and his extensive knowledge of the history behind them, readily available for this project. I was also very fortunate to receive the kind assistance of a few Mill Valleyans whose families featured prominently in local history, in particular Gene Stocking, whose knowledge of the town's past is as remarkable as her readiness to share it, as well as Harvey Klyce, Bud Owen, Robert Bolger, and many others. Local historians contributed their valuable knowledge too, among them Marie Annette McCabe, George Lindholdt, Charles Oldenburg, and Judith Wilson, with a special mention to Jacques Perilhou of Carcassonne, France.

I enjoyed meeting representatives of the dynamic Coast Miwok associations, Sylvia Thalman, Verna Smith, Colleen Hicks, and National Park Service archivist Carola DeRooy, who greeted this project with all-around interest and kindness—that includes Gayle and Malcolm at Heyday Books. A very special thanks to Stephen Becker at the California Historical Society, as well as to Joe Evans, Steve Davenport, and Leigh Golden, and to Alfred Harrison of the North Point Gallery.

The staff at the Mill Valley Library responded with patience and helpfulness to this project. I am grateful to Joyce Crews for her tireless assistance, and to Anne Montgomery, Cathy Blumberg, and Michele Hampshire for smoothing the administrative and technical aspects of this image search. Thanks are especially due to Leonard Berardi, Chuck Chalmers, Paul Chutkow, Dick Dillon, Nicki Evatz, Dorothy Killion, Jim Staley, and Gene Stocking, all of whom spared their valuable time to read drafts of this story and to provide useful suggestions and corrections, and to my Sierra Writers group. It was a pleasure to work with Arcadia's editor Hannah Clayborn, whose guidance and recommendations are always on the mark. Finally, Suki Hill was instrumental in the making of this book, creating beautiful photographs for the opening of each of these chapters, making her collection of old and new Mill Valley images available, and providing her usual boundless creative energy and support.

(Please note: courtesy lines for the Mill Valley Library History Room are abbreviated to MVLHR.)

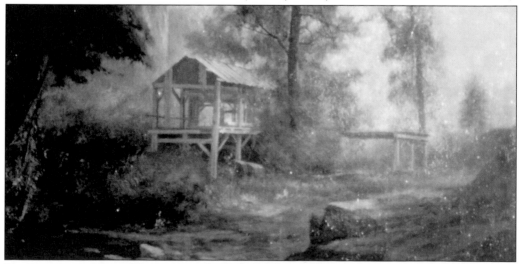

VALLEY OF THE MILL. This painting by Gideon Denny captures the serene setting of the city's oldest structure. (Courtesy California Historical Society.)

INTRODUCTION

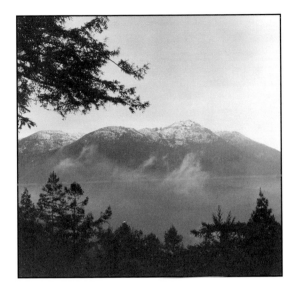

Like every hometown, Mill Valley has its unique palette of colors, smells, and sounds, its special memories and landmarks. There are the deep greens and reds of its redwood groves, the salty taste of ocean winds and fogs, the resonance of the Golden Gate's foghorns. It is the city of the mill, at the convergence of ocean and bay, where the cooler Pacific air meets the warmer interior in a constant churning that creates rapidly changing weather and micro-climates.

Yet Mill Valley is most particularly defined by her mountain, the majestic Mount Tamalpais, that towers over Richardson Bay on one side and the Golden Gate and the Pacific Ocean on the other. The mountain's sloping profile from West Peak at 2,604 feet, to East Peak at 2,586 feet, is a formidable presence in the town's landscape and life. Mill Valley grew where Miller and Blithedale Avenues butt against its rising hillsides, turning into canyons that fan over its flanks. As the gateway to both Mount Tamalpais and Muir Woods, the town became a destination instead of a stop along a thoroughfare.

Mount Tamalpais is a watershed that flows down to the town. Its slopes and peaks and ruggedly beautiful terrain are a spring of inspiration as well. They inspired countless painters who depicted the mountain's beauty, bringing great fame and success to a few like Thaddeus and Ludmilla Welch. It inspired a unique cross-country race, a remarkable mountain theater, an unequalled train ride, and a unique legend, that of the Sleeping Lady, whose outline, turned into a mountainous ridge, daily appears to townsfolk surrounded by sunrise radiance or cloaked in purple sunset skies.

Although arrowheads have been found on the mountain, some old accounts suggest that Miwok natives were in awe of Mount Tam. When American pioneer Jacob Leese climbed to the summit to survey portions of the peninsula, his assistants, "old Indian Chief Marin" and some of his followers, balked at the idea, saying that evil spirits lived there and no one could go up and

come back alive. Chief Marin, compelled to live up to his reputation as the bravest man in the world, tore himself away from his tribe and made the climb, leaving his shirt at the top as proof of his ascent. Since then, many have seen the mountain as a test of their strength.

Many have also found the mountain an exhilarating place for celebration. When Mill Valley's first white child was born in 1833, his father, John Reed, climbed to the top of Mount Tamalpais and erected a large cross that could be seen "all the way to the Farallones," according to family lore. Generations have since used the summit for celebrations, whether to proclaim a victory, like the suffragettes who flew yellow pennants from the peak in 1911; or to pay homage to the dead, like the California Alpine hikers who erected a World War I memorial rock pile; or as a place of worship, like the 500 people who attended the first Easter sunrise service on Mount Tamalpais in 1922; or even like the full moon hikers who used to walk up the mountain by the hundreds after dark.

Each generation used mountain, marshland, and valley in their own fashion, and their unique stories give depth to our daily perception of the town. This collection of old Mill Valley images provides clues toward solving some of the city's mysteries.

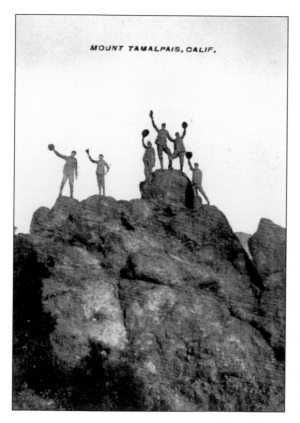

AD SUMMUM MONTEM. In this c. 1910 image, Mount Tamalpais Military Academy cadets wave their caps from the summit to celebrate their motto: *Ad Summum Montem*—I climb to the top. (Courtesy author.)

One

THE FIRST PEOPLE

For perhaps as long as 5,000 to 10,000 years before any Euro-American incursions, the coastal area now called Marin was occupied by scores of Native Americans who called themselves "the First People." According to anthropologist Randall Milliken, this population of perhaps 3,000 people was spread over territories of about 8 to 12 square miles in size. Each territory was controlled by tribelets of a dozen or more villages, with about 60 to 90 members each.

The Marin Peninsula was an Eden-like wildlife habitat. Early French settler Charles Lauff recounted that in 1827 the hills were alive with all kinds of wild game. Elk "thick as bees on the flat in front of Mill Valley," feasted on vast meadowlands of shoulder-high native grasses. Packs of wolves hunted the elk. Bald eagles and giant condors soared above the trees. Mountain lions, bobcats, and coyotes were a common sight, as were brown bears and grizzlies that fed on berries or fished along the creeks during salmon runs.

"In every stream there were fish, on every mountainside there was game, acorns and pine nuts," a historian reported in 1880. According to Lauff, the natives were peaceful and spent much of their time hunting. They lived in proximity to small bays, lagoons, and streams, harvesting fish,

bat rays, sharks, clams, and oysters. Their bows and arrows felled deer, elk, ducks, geese, and rabbits, and their large nets and baskets trapped quail and other game birds. Ground acorns were a staple, used for bread, pies, and mush. Their lives were filled with ever-changing alliances and conflicts with neighboring tribelets, and ruled by headmen, headwomen, and doctors who settled disputes, scheduled dances, and cured illnesses.

The natives' free rule over their plentiful land ended when white men started to appear in 1775.

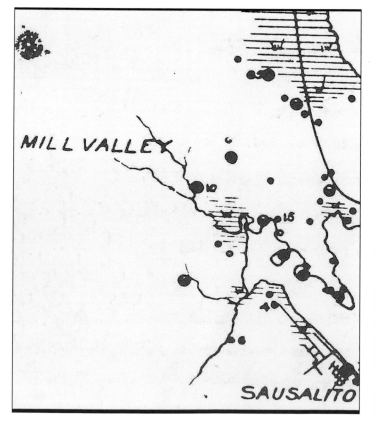

NELSON MAP. Campfire and shellfish debris, accumulated over thousands of years, left dark mounds sometimes a quarter mile long, refuse heaps that were also used as burial grounds. There were quite a few of these "middens" around in the vicinity of Mill Valley, as indicated in historian Nels C. Nelson's map, shown at left. His 1909 record of midden sites locates aboriginal villages, mostly at the edge of tidal mudflats and along creeks. The large dots indicate permanent villages, the smaller ones show temporary camps used a few weeks each year for specific seasonal harvests. Rising bay water submerged the older settlements. (Pictorial history of Tiburon.)

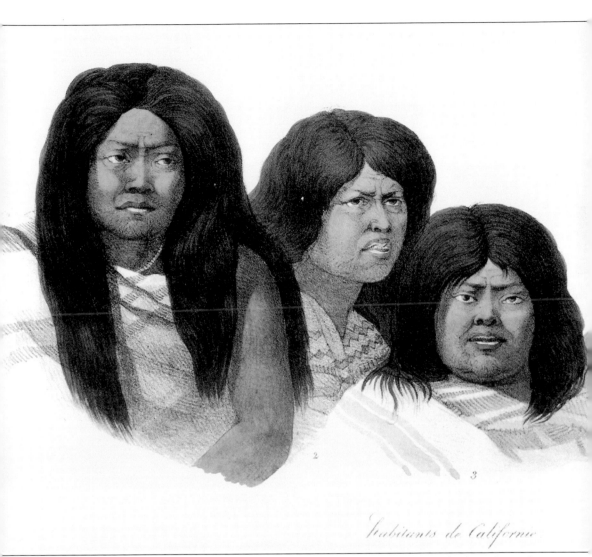

Habitants de Californie

COAST MIWOK. Baptismal registers at San Francisco's Mission Dolores provide clues about the tribal names and territories of Marin's natives, generally referred to as Coast Miwok. Those who lived in the vicinity of Richardson Bay were called Huimen (also spelled Guymen). Their largest villages were Anamas, Naique, and Livaneglua—modern-day Sausalito. Chief Marin, for whom the county was named, was a Huimen. This striking sketch by Louis Choris (1795–1828) portrays "long-time Mission San Francisco neophytes" (converts) who had moved to the mission from their native Richardson Bay. Huimen are seen in numbers 1 and 3. (Number 2 is a Huchiun from today's Oakland area.) Choris's portraits are particularly faithful and lifelike representations, since at the end of his voyage the young artist went to Paris, learned the art of lithography, and lithographed his watercolors himself, which insured that the prints were true to the original. Sadly, Choris was killed by highway robbers while traveling and sketching near Vera Cruz, Mexico. (Courtesy California Historical Society.)

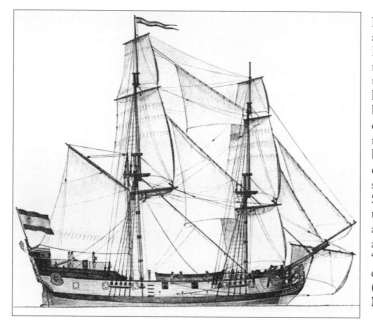

FIRST ENCOUNTER. An astonishing sight welcomed Huimen villagers one morning in August 1775; the Spanish brig *San Carlos* had entered Richardson Bay by moonlight and anchored off its shores. Although the natives came armed with bows and arrows, this first encounter was friendly. The ship's chaplain, Fr. Vicente Santa Maria, befriended them and described them as "men of good presence and fine stature" who were "quite handsome," some even "models of perfection." (Courtesy San Francisco Maritime Museum.)

SAN FRANCISCO DE ASIS. A year later, Franciscan missionaries founded a Mission on the foggy peninsula south of the Golden Gate. Coastal tribesmen came willingly at first, drawn by the padre's gifts and the novelty of their culture. Sometimes they were also brought by force. Once baptized and converted, they were given daily tasks at the mission: gardening, tending cattle, shearing sheep, making utensils, tallow, and soap, transporting supplies between missions, and manning launches across the bay. (Courtesy California Historical Society.)

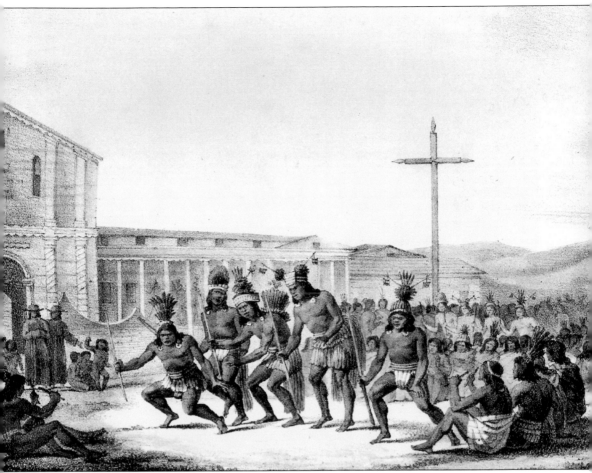

MIWOK DANCERS. So many Huimen tribelets moved to Mission Dolores that their Coast Miwok language became one of the two dominant native dialects of the language group Coastanoan. In 1816, 40 years after the founding of Mission San Francisco de Asis, a Russian scientific expedition sailed on the ship *Rurik*, under Captain Otto Von Kotzebue, into San Francisco Bay. The Russian scientists spent a full month documenting the Spanish outpost, the natives, and their customs. One member of the expedition was Louis Andrevitch Choris, a 21-year-old Ukrainian artist of German-Russian heritage, who had studied art in Moscow. This observant and talented young man depicted the mission's converts, giving their tribal names as mentioned on page 11. He also portrayed one of the rare "pagan" celebrations allowed at the mission during his stay. Dancing was an essential part of Coast Miwok culture. They spent days, nights, even whole weeks dancing, and there were dances for every occasion, every season, every stage of life. One of Marin's last natives, Tom Smith, said in a 1930 interview with author Isabel Kelly that their dances were "so grand" the memory could make him sob out loud. (Courtesy California Historical Society.)

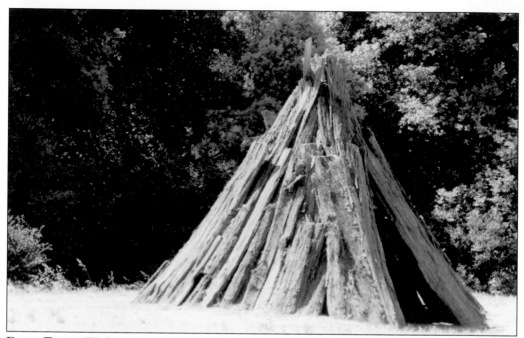

Dark Times. With no immunity to white men's diseases, the estimated 3,000 Miwok natives of Marin and southern Sonoma were quickly decimated by epidemics. In 1817, French explorer Camille de Roquefeuil reported that "there was not a single mission where births balanced deaths." By 1840, Marin's Miwok population, including the tribelets that lived on the Mill Valley mudflats, had been reduced by 90 percent, their redwood bark *kotchas* forever deserted. (Photograph by Selene de Filippis.)

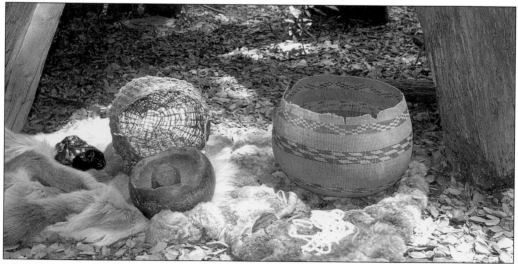

Miwok Legacy. Despite the decimation, the Coast Miwok and their traditions have endured. Precious artifacts are preserved at the Marin Museum of the American Indian, opened in Novato's Miwok Park in the 1960s. The museum, which focuses on both local and non-local Indian culture, displays the artifacts seen here: a tightly-woven cooking basket made to hold water, and a block of obsidian flaked for arrowheads and spearheads similar to those found in Mill Valley. (Courtesy Marin Museum of the American Indian.)

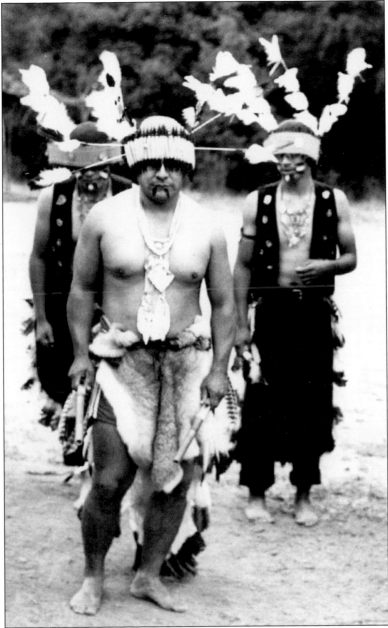

TRIBAL REVIVAL. When the 1954 California Rancheria Act ended federal trusteeship for native Californians, the official status of the Coast Miwok was terminated. But a revival of Miwok culture and ethnic pride led the tribe's descendents to apply to the U.S. government for recognition of their tribal government. The last omnibus bill signed by President Clinton in 2000 restored all federal rights and privileges to Coast Miwok who can trace their lineage to an 1852 census. These modern-day Miwok dancers renew their spirits in ancestral ways and celebrations as they were practiced by the ancient inhabitants of Richardson's Bay. The name Tamalpais meant Land of the Tamals, according to a history published by Hubert Howe Bancroft in the 19th century. More recent research suggests that it may also mean West or Bay Mountain. (Courtesy National Park Service.)

THE OLD WAYS. These descendants now keep the old ways alive, and the Miwok Archeological Preserve of Marin (MAPOM) plays a central role. Founded in 1970 after an excavation of a Coast Miwok village site, the association published several works on Miwok Indians and archeology including Isabel Kelly's field notes. MAPOM members like Sylvia Thalman, pictured here holding a hawk feather cape, also performed important genealogy research that enabled the tribe to become federally recognized. (Courtesy National Park Service.)

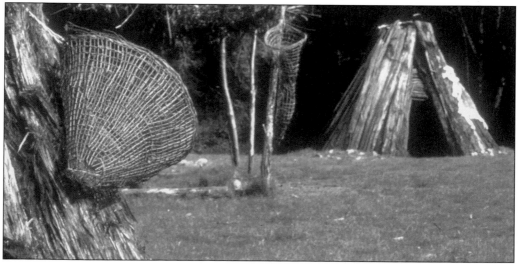

KULE LOKLO. There were still a few groups of natives around Richardson Bay in the 1820s. Auguste Lauff recounted how they helped John Reed build his mill, made adobe bricks for his house, and went hunting with William Richardson. Native villages around the Mill Valley area looked like this interpretive re-creation of a Point Reyes Coast Miwok Village called Kule Loklo—Bear Valley—with *kotchas* built of redwood slabs, granaries, and a sweat lodge. (Courtesy National Park Service.)

Two

REDWOOD RANCHO

By 1834, there were 21 Missions in California, with a total of 31,000 Indian converts. That year, California's Mexican governor Figueroa abolished the mission system. Padres and neophytes were dispersed and mission land was subdivided and granted to settlers. Between that date and the American annexation, the territory that is now Marin County was carved into 23 grants totaling 330,000 acres.

These grants were huge, free, and with the right connections, relatively easy to obtain. California's population was small, and land seemingly limitless. Grantees had to be Mexican citizens, Catholic, and male. The grants were recorded on rough, hand-drawn maps called *diseños*, using natural landmarks as boundaries. Traditionally a grantee took possession of the land by riding around its perimeter in the presence of an official and several witnesses.

There were a few *estrangeros*—non-Hispanic foreigners—among these grantees. Spain, and later Mexico, was very reluctant to authorize settlement of foreigners in California. Only a handful of seamen and fur trappers had become landowners since 1818, and those usually married *hijas del pais*, daughters of landowning families.

In the 1820s, two seamen central to the history of Mill Valley sailed into San Francisco Bay, John Reed and William Richardson. Both married into the family of then-Presidio *Comandantes*, both acquired Mexican citizenship, and both were granted large tracts of land covered with immense redwood trees. The timber provided building material, and game and Mexican cattle allowed them to deal in the lucrative hide and tallow trade described in Richard Henry Dana's classic *Two Years before the Mast*.

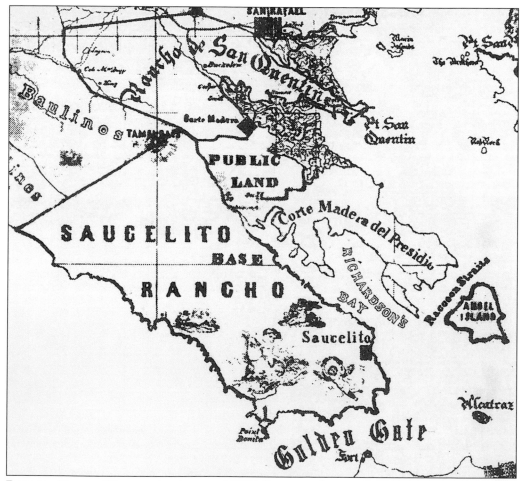

RANCHO NAMES. The area that became Mill Valley sits at the junction of Rancho Corte Madera del Presidio ("where wood is cut for the Presidio"), granted to John Reed in 1834, and Rancho Saucelito, granted to William Richardson in 1838. Today's assessor's maps for Mill Valley property still bear these original rancho names and, as Barry Spitz noted in his book *Open Spaces*, half of today's Open Space District Preserves have boundaries that exactly match the old Mexican land grant lines. (Courtesy E. Peninou.)

JOHN REED. Reed may have looked like a blond version of his son John Joseph (pictured next to Hugh Boyle, right [see page 25]) in this 1870 picture. Esteban Richardson described him as tall and well proportioned, with deep blue eyes, a good complexion, and crisp blond hair. Born in Dublin, Ireland, in 1805, Reed went to sea at 15, lived in Acapulco until 1826, then sailed to Los Angeles and Yerba Buena (now San Francisco). An experienced pilot and local trader, Reed ferried supplies, people, and fresh spring water across the bay. (Courtesy MVLHR.)

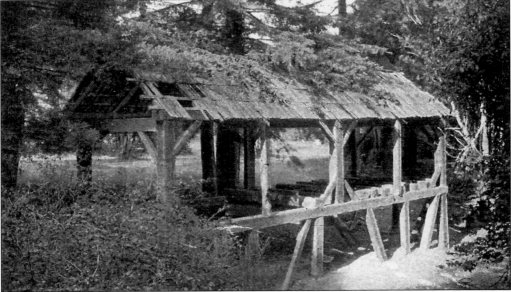

REED'S MILL. Around 1834, when he needed lumber to build his home, John Reed built a sawmill over the raging waters of today's Old Mill Creek. He and his Indian workers probably labored a year to hew the redwood into square beams, another to assemble 48-foot beams, each weighing three tons, with oxen and block and tackle. Now California's oldest surviving mill, it was also the first in the Bay Area to provide milled lumber. (Courtesy author.)

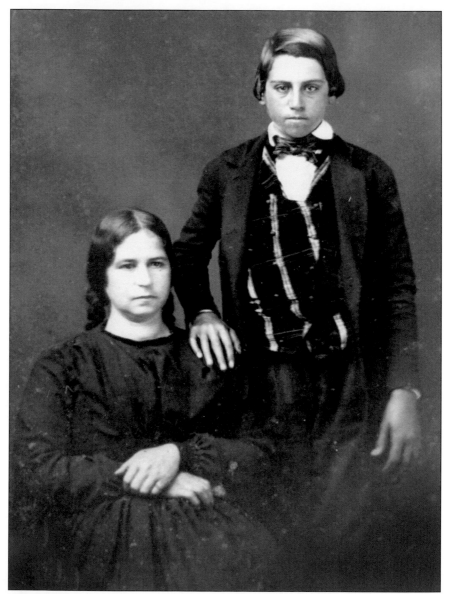

HILARIA REED. Hilaria was 13 years old when John Reed first landed at the Presidio. The Irishman befriended her father, Antonio Sanchez, *Comandante* of the Presidio, and often visited the Sanchez family. In October 1836, after a 10-year courtship, 31-year-old Reed married 23-year-old Hilaria at Mission Dolores. Charles Lauff recalled: "I was the first white man to work for John Reed Sr. (as a whip sawyer). Reed was a very kind and good man, a great friend of Richardson's at Sausalito and Murphy's at San Rafael. He married a Spanish lady . . . He was a fine specimen of manhood and she was the most beautiful bride I ever saw." Reed brought his bride to his newly built adobe at what is now La Goma and Locke Lane. They became Mill Valley's first non-native family, and the only one around for quite a while, with their four children: John Joseph, born in 1837, shown here at age 16 with his mother; Ricardo, born in 1839 and died in 1853; Hilarita, born in 1840, and Maria Inez, born in 1841. Reed Avenue was named for the pioneer, and Corte Madera Avenue ("where wood is cut") and the town name both memorialize his pioneer mill. (Courtesy MVLHR.)

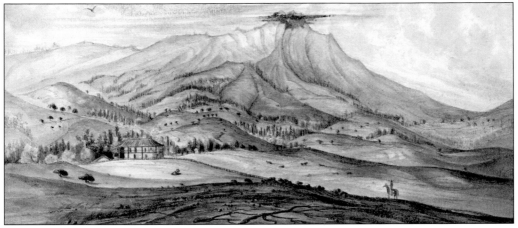

MILL VALLEY'S FIRST HOME. The industrious young Irishman must have loved his land, considering how eagerly he set out to improve it. Between November 1835, when he took possession of the grant, and his untimely death in June 1843, he managed to build a mammoth mill, two adobes, two corrals, and a half-finished barn. He planted grain and an orchard. He kept salt yards, a brickyard, even a stone quarry. He raised 60 horses, and 400 cattle for their meat and hides, and since Mexican cows were notoriously too restive for milking, sent for dairy stock from England. A European explorer visiting the North Bay in 1841 recalled that Reed had trained his cattle to gather to the sound of the Irish national anthem, which he played on a bugle every evening. By 1843, John Reed began building a larger home for his growing family. The new adobe was 45 by 25 feet, with walls three feet thick. Each level had three rooms, and a double veranda ran around the house in Spanish Colonial style. There were roses in the yard and an almond tree in the back. It was close to Warner Creek, where the Reeds did their washing, and to the navigable salt marshes. A landing on a nearby slough provided easy access for visitors and guests. John Reed would never see it completed. He died on June 29, 1843, at age 38, after falling ill and being improperly bled. (Courtesy Yale University, Beinecke Rare Book Library.)

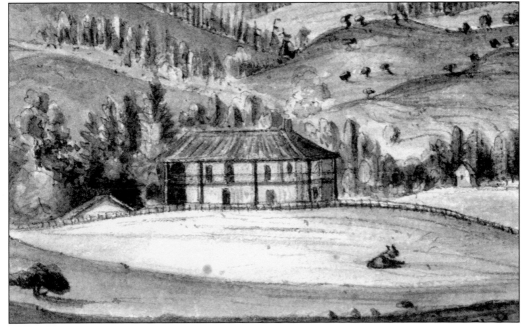

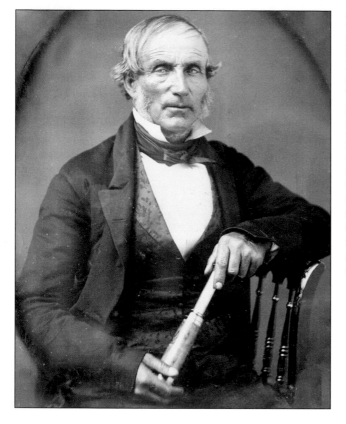

RICHARDSON'S RANCHO. Born in London in 1795, William Richardson sailed into San Francisco Bay in 1822, as mate of the British whaler *Orion*. Two years later, he built the first house in Yerba Buena, becoming its first harbormaster. He married Maria Antonia Martinez, the Presidio *Comandante*'s daughter, in 1825, and, in 1838, they moved to the bay's north shore to settle a 19,000-acre grant stretching from the Pacific Ocean to Corte Madera Creek, from present-day Sausalito to the slopes of Tamalpais. (Courtesy California State Library.)

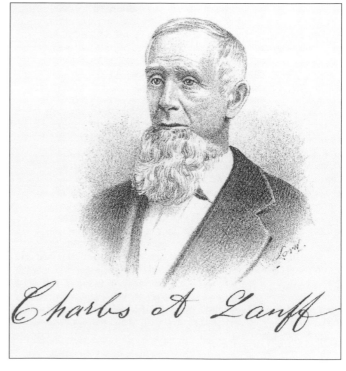

CHARLES AUGUSTE LAUFF. Born in Strasbourg, France, in 1822, Lauff sailed to New York with his widowed mother when he was 12. After studying in public schools, he sailed on an American bark, bound for a wandering life full of adventures that eventually brought him to San Francisco in 1844. He hunted with Richardson in the hills of Mill Valley, recalling the Londoner was "a great hand with the *riata* and always had several Indian cowboys on his hunts." (Courtesy E. Peninou.)

SAMUEL R. THROCKMORTON. Already 41 years old when he joined the forty-niner rush, this New Jersey native quickly abandoned mining for real estate, living in San Francisco with his wife, Susanna, and their three children. In 1855, William Richardson, sick and plagued by business, put his mortgaged rancho into Throckmorton's hands. When Richardson died eight months later, his heirs allowed Throckmorton to sell their land, which he did, reserving about 13,000 acres extending from Tennessee Valley to Mount Tamalpais for himself. (Courtesy MVLHR.)

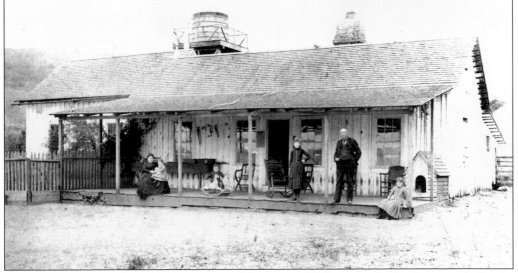

THE HOMESTEAD. Throckmorton, an avid hunter and fisherman, built a hunting lodge (at present-day Linden Lane, Montford, and Ethel Avenues) in 1866. The fenced slopes of Mount Tamalpais were maintained as a private preserve for himself and privileged guests. The ranch overseer, Jacob Gardner, lived at the Homestead with his family, seen here. From left to right are Annie Gardner holding baby Lillian Margaret, Leslie, Georgina, Jacob Gardner, and Cora Elizabeth. Lillian became Mill Valley's first librarian. (Courtesy MVLHR.)

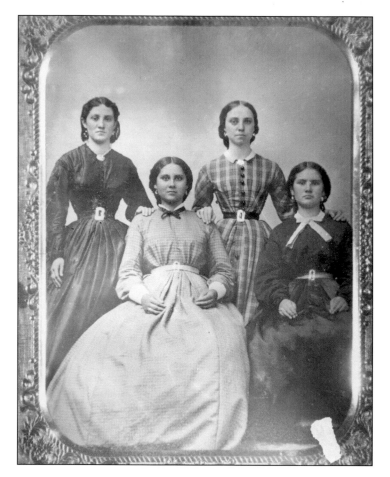

HILARIA'S DAUGHTERS. John Reed's widow and children reportedly owned piles of rough-hewn tree trunks ready for sale, plenty of salted meat for ships, and no less than 4,000 heads of cattle "in very good shape." In 1845, she married Bernadino Garcia and had one more daughter, Carmelita. Both her husband and her son Ricardo died in 1853. Shown here, from left to right, are Maria Inez Reed, Barbara Sibrian (who bore John Joseph an illegitimate child), Hilarita Reed, and Carmelita Garcia. (Courtesy MVLHR.)

CONTESTED HERITAGE. Falling on hard times shortly after John Reed's death, Hilaria put the rancho up for sale in September 1850. Benjamin R. Buckelew, who bought the property for $35,000, defaulted on the monthly interest he owed. Hilaria enlisted her friends to help regain the rancho, and one year later, a court order returned the property to the Reeds. It was not until February 1885 that their original grant of 7,842 acres was confirmed by the Land Commission. (Courtesy E. Peninou.)

PUBLIC SALE OF REAL ESTATE.— By virtue of order issued to me by the Probate Court of Marin County, in the State of California, there will be sold at Public Auction on SATURDAY, the twelvth (12) day of October, 1850, at 12 o'clock, M., on the premises, for the benefit of the heirs, the entire landed estate of John Reed, deceased, containing two leagues of land, more or less, situated in the aforesaid county, between Sausolito and San Raphael, and adjoins the ranches of Capt. Wm. Richardson and Capt. J. R. Cooper, and the Bay of San Francisco. There is belonging to said estate one dwelling house, two corrals, from one to two thousand head of cattle, about two hundred head of horses, mares and colts, and a considerable quantity of oak and redwood. Terms cash. Other particulars made known on the day of sale.
JOHN S. GIBBS,
Administrator and Guardian.
SAN RAPHAEL, Marin Co., Sept. 19, 1850.
sep21-21*

GOLD RUSH BONANZA. As waves of immigrants poured into California in the early 1850s and San Francisco roared to life, raising cattle for the hide and tallow trade became no longer profitable. Instead the population explosion created a great demand and premium prices for dairy, meat, and lumber. Marin's vast ranchos were progressively turned into smaller dairy ranches, free-roaming longhorn cattle were replaced by fenced dairy cows. By 1850, 20 percent of all butter produced in California came from Marin. By the 1860s, both the Reed and Richardson ranchos were devoted to dairying. Carmelita Reed and her husband, Hugh Boyle, built a home on a choice knoll overlooking today's Boyle Park. This early photograph shows their mansion, Cypress Knoll, and dairy cows grazing where Park School now stands. Cypress Knoll is now Mill Valley's oldest, non-adobe home, with its own unsolved mysteries. During the course of remodeling in 2004, two late-1800s coffins with (well-dressed) human remains were found under this house. No one knew who they were, and the coffins were returned to their resting place. Not far from Carmelita Street, Manor Terrace and Manor Drive were named for the mansion. Nearby Sarah, Sidney, and Juanita Streets were named for the Reeds' grandchildren. (Courtesy MVLHR.)

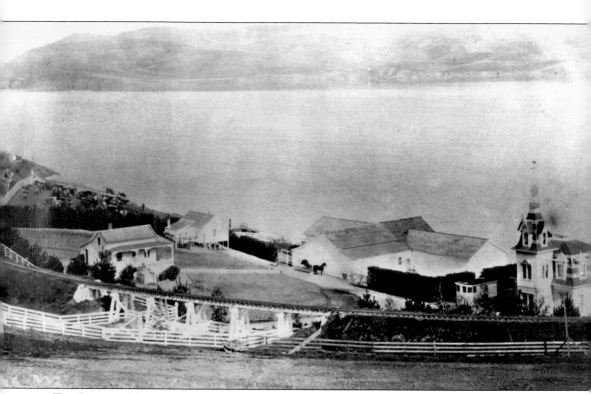

THE LYFORDS' EAGLE DAIRY. Upon Hilaria's death in 1868, the Reed property was divided up among her children. Her oldest son, John Joseph, received 2,000 acres of land in the northern part of present-day Tiburon. Hilarita, who married Benjamin Lyford, inherited 1,000 acres at the southern end of Tiburon and Strawberry. Maria Inez moved into the Reed adobe at La Goma with her husband, Thomas Deffebach, and like her siblings, ran a dairy ranch on the 646 acres of land that surrounded the home. Their half-sister Carmelita Garcia, who was married to Hugh Boyle, received 325 acres, also in Mill Valley. All of Reed's children, the Reeds, Lyfords, Deffebachs, and Boyles, turned to dairying, producing butter, cheese, milk, and cream that fetched handsome prices in San Francisco. This 1895 photograph shows Eagle Dairy, the Lyford ranch at Strawberry Point. Benjamin Lyford and Hilarita lived in this beautiful Second Empire–style home from 1876 to 1906. In 1957, the house was loaded on a barge and towed a half mile across the bay to its new home at Rogers Beach where it was restored and turned into a Victorian house museum. (Courtesy MVLHR.)

DAYS OF THE LUMBERJACKS. Six fires raged through San Francisco between 1849 and 1851. Lumber was needed to rebuild the town, as pilings for wharves, foundations for homes built on filled land, as cordwood for stoves and for the blubber vats of whaling ships. Charles Lauff reminisced, "The country around Mill Valley and Muir Woods was covered with immense trees," adding that the vanished forests were "the grandest sight one could rest eyes upon." The job for man and beast of cutting down the massive old growth was arduous without modern tools or vehicles. (Courtesy author.)

TO HOUSE and Wharf Builders. The subscribers offer for sale at the warehouse, foot of California street, every description of red and pine wood Timber and Spiles, suitable for Wharf and Building purposes; deliverable on the beach.
f1 S. H. WILLIAMS & Co.

TIMBER, PILES, &c. 150 redwood piles, long and straight; 15,000 feet redwood square timber, 10x10 to 12x12, 24 to 30 feet long; 30,000 feet pine do 12x12, 30 to 60 ft long, for sale low, by BLACKBURN & THOMPSON,
nov22-7 corner of Pine and Battery sts.

REBUILDING SAN FRANCISCO. Due to this insatiable demand, lumber fetched hefty prices and was commonly advertised in San Francisco's newspapers. Lumber felled in Mill Valley was loaded on barges at a wharf built on the site of the present Tamalpais High School, then shuttled across the bay and sold right off San Francisco's piers. According to Barry Spitz, the Parker House, San Francisco's largest building, was built with lumber from Mill Valley. (Courtesy E. Peninou.)

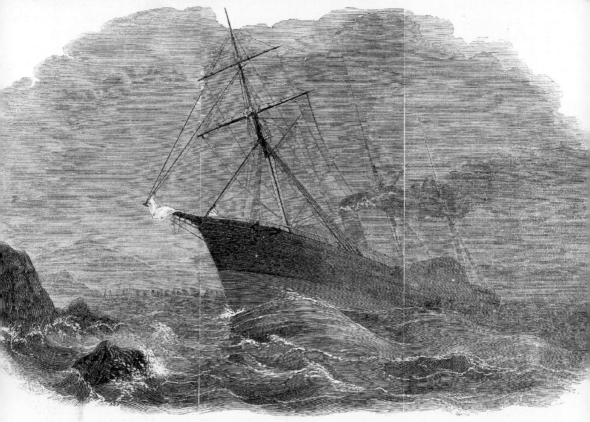

WRECK OF THE STEAMSHIP TENNESSEE, AT SAN FRANCISCO, CAL.

WRECK OF THE TENNESSEE. Fogs were so prevalent at sea near San Francisco, that ships and steamers were forced to navigate without visibility or remain outside the entrance for sometimes days on end. On April 6, 1853, a 2,000-ton side-wheeler plying from Panama by the Pacific Mail became lost in dense fog in the vicinity of the Golden Gate (long before the bridge was built) and ran aground on a sandbar. The violence of the surf dashed any hopes of recovery. A line carried to shore allowed all 600 passengers, the mail, and 24 chests of gold to land safely. A camp was set up, with tents and screens for the ladies, and news was sent to San Francisco. A steamer reached the wreck the next morning, embarking all passengers safely back to San Francisco. The steamship was never recovered, in spite of a $4,000 reward the company offered. And so the *Tennessee* gave its name to the beach, which remains one of Mill Valley's popular walking destinations. Pieces of the wreckage were found nearly 130 years later, buried in sand and water. (Courtesy author.)

Three

SUMMER RESORT

Reed's mill and adobe, Throckmorton's hunting lodge, and a few scattered dairy ranches were all there was to Mill Valley in the 1850s and 1860s. From that time until the turn-of-the-century, Marin was the number one dairy county in California, with 25,390 cows, according to an 1889 San Rafael Chamber of Commerce report. Heavy lumbering had denuded Mill Valley's hills and turned them into excellent pastures. Dairy cows grazed everywhere from downtown to Tamalpais Valley, from Homestead and Almonte to Strawberry.

Newcomers complained about these thousands of privately owned acres dedicated to dairying. Yet, the dairies effectively protected Mill Valley and vicinity from rampant subdivision and construction. Although Marin's population rose to 11,320 by 1880, and towns like Corte Madera and San Rafael boomed, Mill Valley remained relatively undisturbed, a small quiet place off the beaten path. The North Pacific Coast Railroad that opened in 1875 actually skirted Mill Valley and would not lay a spur into the town until 1889.

A mere handful of permanent residents lived in Mill Valley, but hundreds of visitors came to hunt (prohibited after 1917), hike, and camp, descending on the town in the summer. These

"pilgrims" summered in the country under a tent, clear skies, and magnificent trees, away from San Francisco's fog in the bucolic countryside that provided endless opportunities for walks, hikes, and horse and buggy rides. The small settlement acquired a growing reputation for pristine surroundings favorable to health and ideal for extended summer stays. Then Mill Valley became home for the "crookedest" railroad in the world, and it would never again be the same.

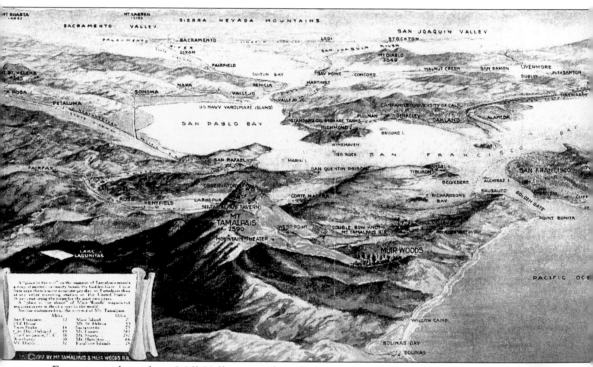

From its earliest days, Mill Valley served as the gateway to Mount Tamalpais. And from the earliest days too, the mountain was a magnet for those bold enough to hike up to its top. The endless diversity of the panoramic view from the summit, constantly changed by weather and light, has enchanted many generations. Hikers, picnickers, painters, and poets tried to capture it with words, paintings, or photographs—or with maps, such as the one seen below, that provides bird's-eye distances to the major points of interest visible from the crest. With old-fashioned, flowery prose, the map's commentary also extols a few familiar sights, like the "infrequent" days when an ocean of fog sweeps the earth from sight "and one seems to be the sole survivor on an island in the sky." It describes views that can no longer be experienced today: "On a clear day one may glimpse great steamships flying the flags of many nations, riding at anchor within the Gate, and other vessels unfurling their wings for foreign shores. Many miles southward, in California's fair fruit-blossom time, are miles of billowy bloom, foaming like the waves that break on the beach far below the top." (Courtesy author.)

BLITHEDALE SANITARIUM. Rhode Island homeopathy specialist Dr. John J. Cushing came to San Francisco shortly after the gold rush. In 1873, he retired to a 342-acre homestead, where he erected his residence and cottages for friends and guests, soon reputed to be California's best spot for recreation and convalescence. The beauty of the surroundings inspired him to name it after the New England utopian community, Brook Farm, immortalized as "Blithedale" in his classmate Nathaniel Hawthorne's 1852 romance. (Courtesy Jim Staley.)

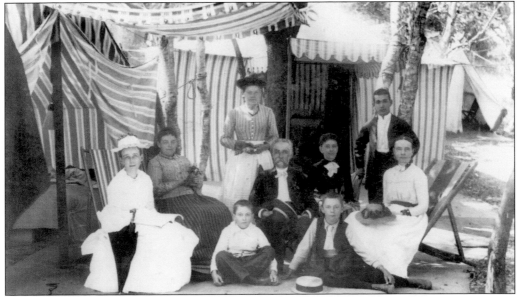

THE BLITHEDALE HOTEL. Upon Cushing's death in 1879, his son Sidney turned the sanitarium into a summer resort. The cottages were leased to affluent San Francisco families, while other guests, like the Stewart family shown here in 1890, sojourned in tents with rustic furnishings. The resort boasted accommodations for 125, a billiard room, a pond, tennis and badminton courts, and a bowling alley. Mill Valley's first hotel quickly became one of the most celebrated in Northern California, with San Francisco magnate Adolph Sutro among its famous guests. (Courtesy MVLHR.)

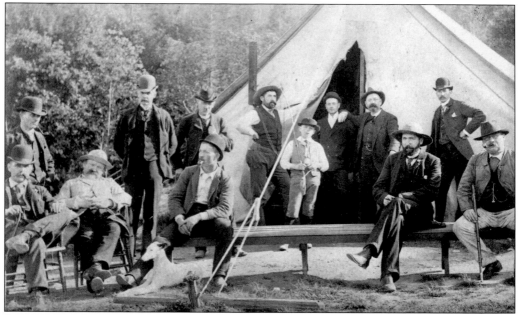

SUMMERING IN MILL VALLEY. Mill Valley was a popular and bustling summer destination, even for those who could not afford the Blithedale Hotel. The 1890 auction increased the number of campers—to the despair of local newsmen: "The woods and cozy retreats are thickly studded with tents . . . Alas for the quiet and primitive aspect of our valley even one short year ago." In this *c.* 1890 photograph, noted Sausalito poet Daniel O'Connell relaxes with friends at their rustic campground. (Courtesy MVLHR.)

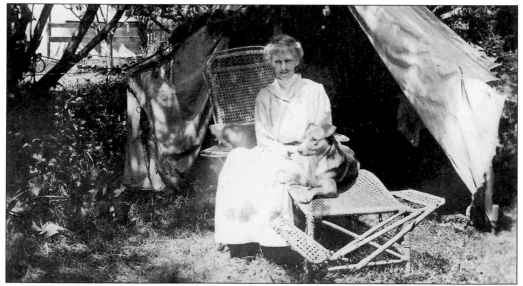

CAMPFIRE PARTIES. Most early Mill Valley residents spent their summer outdoors, like Hertha Meyer and her family, who slept "in comfortably equipped tents tucked away under the tall redwoods, enjoying our meals beneath the large azalea. Our water supply came from a spring near our dining table. In front of the cabin a place had been cleared for camp fires although we cooked on a convenient coal oil stove: campfire parties with long stories and light refreshment were our chief amusement in those care-free days." (Courtesy Jim Staley.)

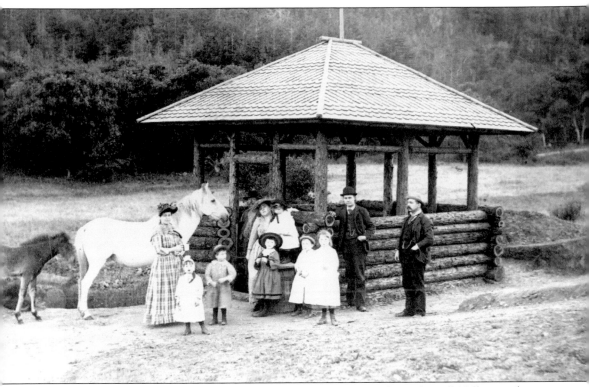

A SULFUR SPRING. Word of a sulphur spring—discovered in 1891 by early Mill Valley resident "Doc" Beeman—spread through Marin County, and entire families soon came armed with bottles and demijohns that they filled with the mineral water, thought at the time to restore health and vigor. In 1895, determined to turn the town into a health spa, the Mill Valley Mineral Springs was incorporated with a capital stock of $1 million. A gazebo was built over the spring with the potent rotten egg smell. Alas, the new company had very limited commercial success, and the spring was paved over in 1921 (see page 87). (Courtesy MVLHR.)

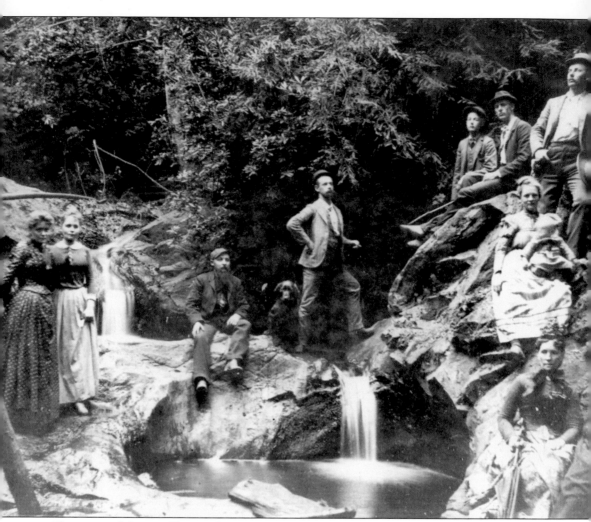

HIKING ON MOUNT TAM. Hiking was truly one of the favorite pastimes of the 19th century. According to historian Lincoln Farley, crowds of up to 3,000 visitors, several times the number of year-round Mill Valley residents, were not uncommon on summer weekends in the 1890s. They thought nothing of hiking from Mill Valley to the Redwood Canyon (as Muir Woods was called) and back. The Lundquist family above is resting after just such a hike, by the Three Wells, a series of shallow pools eroded into Cascade Canyon's bedrock. An age-old conflict had already appeared on the trails: an 1892 *Sausalito News* columnist laments that he feared "slaughter beneath the hoofs of goaded horses," and "the demon cyclist with his pneumatic tires being upon us unawares." (Courtesy MVLHR.)

HEADING UP THE MOUNTAIN. Mount Tamalpais was, of course, the prime hiking destination. Trails were graded, and taverns appeared, facilitating both hiking and burro rides up the two peaks. For climbers who did not care to walk, the Mill Valley Burro Company, incorporated in 1893, offered "well trained burros" with poetic names meant to fit their personalities. Lorelei, Maude, and Nasturtium sound like easy rides, as opposed to Bismark and Dynamite Pete. (Courtesy MVLHR.)

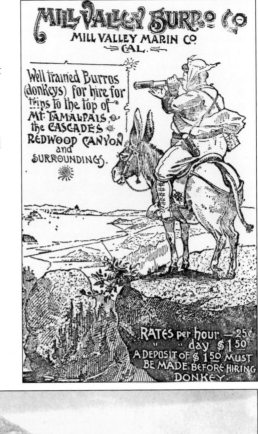

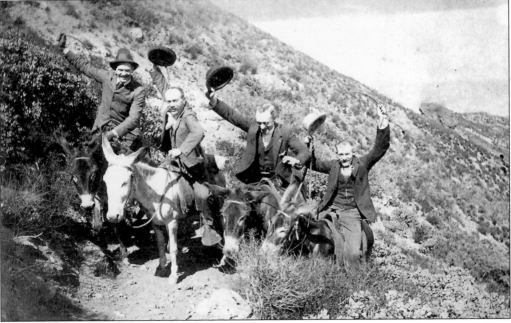

RIDING TO THE TOP. According to accounts of that period, no matter how hard they were prodded, donkeys were slow as mud, never moving faster than a jog-trot that "made sitting uncomfortable for many a San Franciscan for days afterwards." These four hardy weekenders do not seem to mind. (Courtesy Jim Staley.)

BOHEMIAN AND ARTIST HIKERS. Artists of every ilk were attracted to Mount Tamalpais. Ambrose Bierce, Bret Harte, Joaquin Miller, and other San Francisco bohemians were regular hikers in the 1870s. Among them too were artists Paul Frenzeny and Jules Tavernier, who published a sketch of the mountain in an 1875 issue of the famed *Harper's Weekly*. (Courtesy author.)

A RUSTIC LIFESTYLE. Two decades later, painters Thaddeus and Ludmilla Welch built this picturesque, albeit rustic cottage on Mount Tamalpais's hillsides, and began painting poetic rural scenes of mountain pastures and grazing cows. They christened their site, Steep Ravine. A water wheel on Weber Creek supplied water to their cabin, which became one of Ludmilla's favorite subjects. This simple lifestyle emulated the ideals of the increasingly influential arts-and-crafts movements of their era. (Courtesy Richard Dillon.)

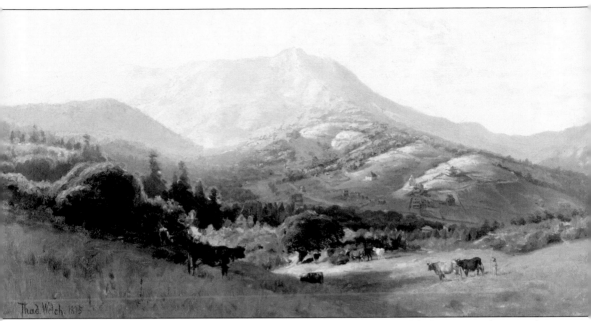

Thad. Welch. 1895

MOUNT TAMALPAIS, 1895. Born in LaPorte, Indiana, Thaddeus Welch (1844–1919) crossed the plains in a covered wagon at age three, settling with his family in Oregon. His obsession with painting led him from his father's farm to San Francisco and William Keith's teachings, to Munich, Germany, where he studied for four years. At age 39, he fell in love and married his 16-year-old student, Ludmilla. The couple lived in Boston for a few years before heading west, first to Los Angeles, then to San Francisco in 1894, and to the newly established town of Mill Valley. It is on the slopes of Mount Tamalpais that the painters found their inspiration and ultimate success. Although critics facetiously identified their paintings by the number of grazing cows they depicted, the couple's artistic skills blossomed, their pastoral landscapes attracting the praise of art critics and collectors across the country. Besides the mountain's grass-covered hillsides, this 1895 painting entitled, *Mount Tamalpais*, shows the small town of Mill Valley in the background, with the distinctive square shape of Summit School visible in the center. Art historian Alfred Harrison characterized Thaddeus Welch as "a painter of talent and sophistication, who had a sympathetic feeling for the beauty of nature." In 1905, due to Thaddeus's health, the couple was forced to seek a milder climate and moved to Santa Barbara. (Courtesy Pat Gibbs.)

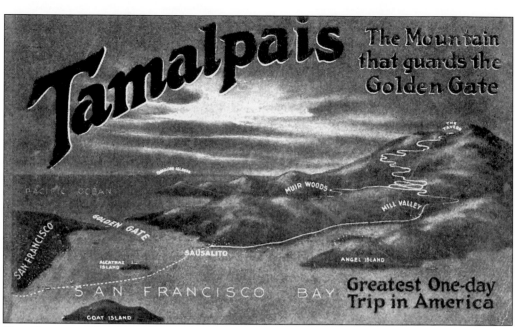

THE GREATEST ONE-DAY TRIP IN AMERICA. In 1896, the mountain that stood sentinel to the Golden Gate became the entire nation's favorite destination when an 8.25-mile standard gauge rail line was built from Mill Valley to its summit. The two-hour excursion consisted of a half-hour steamer ride from San Francisco, connecting in Sausalito with a train to Mill Valley where passengers transferred to the steam train that took them up the winding track to the Tamalpais Tavern at the summit. It cost $1.90 round trip. (Courtesy author.)

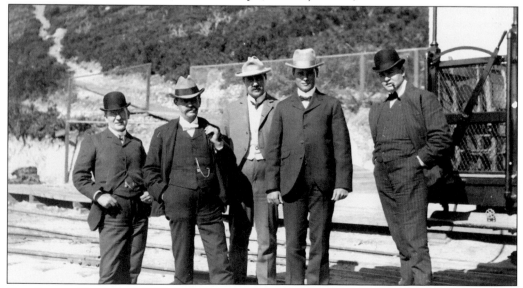

THE SCENIC RAILWAY'S VIPs. The concept of a mountain train to the summit of Tamalpais was first presented by Louis Janes of the Tamalpais Land and Water Company. Blithedale Hotel owner, Sidney Cushing, was the driving force behind the project. Albert E. Kent granted right of way through his land. The company was incorporated in January 1896. Shown above, from left to right, are Charles Runyan, Lovell White, Sidney Cushing, William Kent, and Louis Janes, founders of the Scenic Railway. (Courtesy MVLHR.)

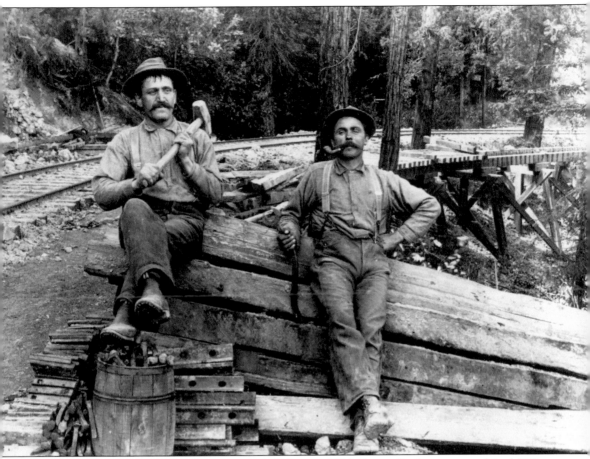

TRACK LAYERS. Construction began in early February 1896. Scenic Railway owners hired 200 workers, most of them Irishmen, and paid them $1.75 for each 10-hour day they spent fastening 30-foot-long, 57-pound steel rails to large redwood ties. But they only netted $1 per week after purchasing their food and supplies from the company store. Work was temporarily halted when they walked off the job, perhaps because hot lunches were no longer free, or perhaps, as the legend goes, to protest the way the Chinese cook prepared potatoes. The cook was fired, construction resumed at a brisk pace, and the railroad was completed in only eight months, by August 22, 1896. (Courtesy MVLHR.)

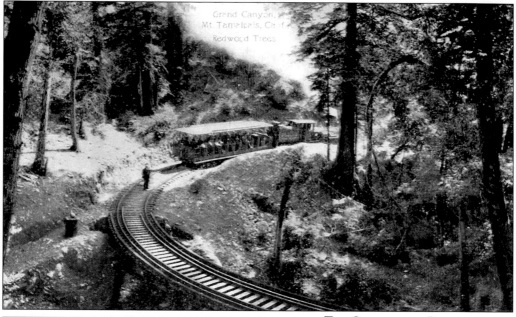

THE CROOKEDEST RAILROAD IN THE WORLD. The Mount Tamalpais Railroad quickly earned that nickname, since its route included 281 curves. Two of these, Double Bow Knot (which was pictured in the railroad logo) and Horseshoe (above), were engineering marvels. The former had a view of the redwood canyon below, where the line paralleled itself, switchbacking five times in about 300 feet. The latter had a 90-degree curve with a radius of 70 feet. (Courtesy author.)

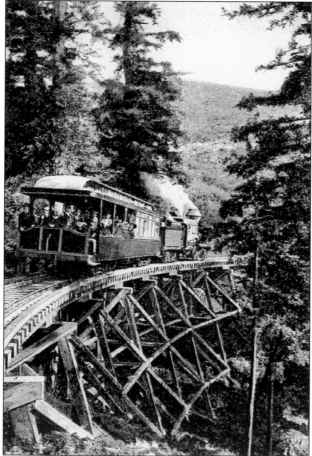

A BEAUTIFUL RIDE. The climb was gentle, with an average grade of six percent. It crossed Corte Madera Creek eight times, went in and out of redwood groves, chugged over a total of 22 trestles, all the way to West Point, where an inn was built in 1904, and to the Tavern of Tamalpais. From the summit terminus at 2,436 feet elevation, travelers had a commanding view of mountains, ocean, and bay. (Courtesy author.)

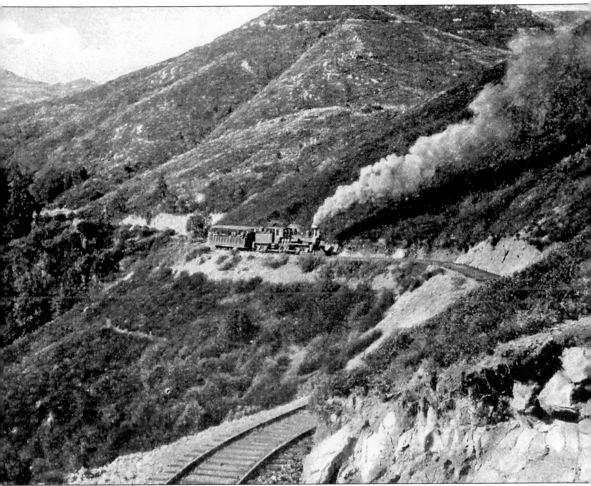

Climbing Tail First. Early scenic postcards often had trains drawn into the card, but the odd direction of the locomotive's puff of smoke is not an artist's error. The mountain train actually pushed its cars upslope. The engine was always at the rear of the train, insuring safety from breakaways, freedom from smoke and soot, and an unobstructed view. (Courtesy author.)

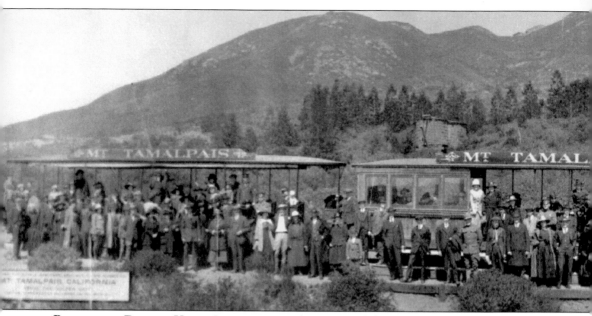

PAUSING AT DOUBLE KNOT. Locomotive and train posed for the photographer on the way up for a memento of what barkers on the train called "The biggest little journey in the world." The

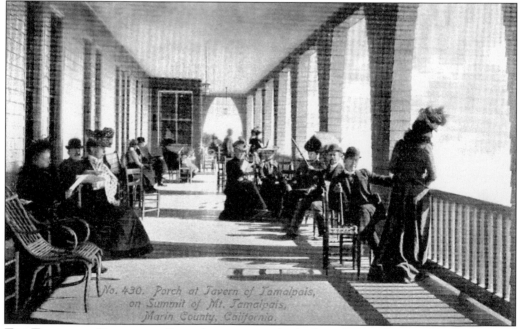

No. 430. Porch at Tavern of Tamalpais, on Summit of Mt. Tamalpais, Marin County, California.

THE TAVERN OF TAMALPAIS. Several taverns were built along the way for passengers to rest and admire the sights. The Tavern of Tamalpais was erected in 1897, high on a sheltered nook, close to the summit. It overlooked a grandiose panorama, especially popular at sunrise, "a panorama unique in its beauty and grandeur and without parallel in the world." (Courtesy Jim Staley.)

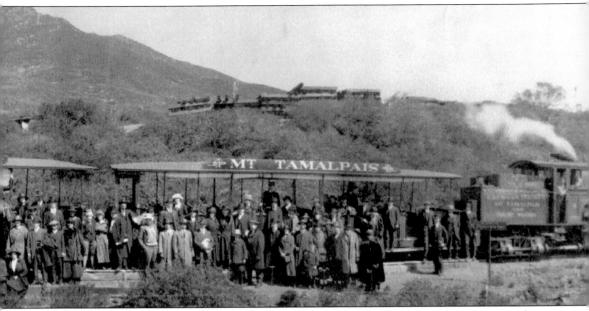

tank with spout behind the train is where engines obtained water. The structure on the top right is a pile of tracks. (Courtesy MVLHR.)

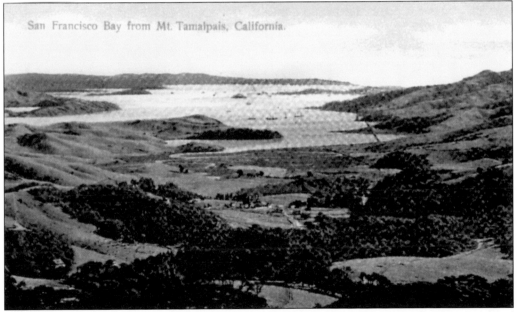

San Francisco Bay from Mt. Tamalpais, California.

ABOVE THE CLOUDS. This 1890s view showing schooners in Richardson Bay lives up to a local newspaper's rapturous description: "No song, no story, no picture can impart the effect upon the sense's experience. The buoyancy of the atmosphere, the exhilaration which one experiences in breathing deeply of the pure air wafted from the broad Pacific, cannot be described." (Courtesy Jim Staley.)

MUIR WOODS. In 1905, William Kent purchased the popular Redwood Canyon to preserve its giant redwoods. Two years later, apprised of a plan to create a reservoir there, Kent deeded 300 acres to the U.S. government. A new law allowed Pres. Theodore Roosevelt to turn it into a federal preserve named for John Muir. Shown, from left to right, are John Muir, William Kent, and Tamalpais Conservation Club president J. H. Cutter. (Courtesy MVLHR.)

TRAINS TO MUIR WOODS. By 1807, a spur of the mountain train was ready to take full advantage of the scenic wonders of the newly created federal preserve. The combination of views of the bay from the top of Mount Tam and the scenic beauty of the redwoods made it an instant success. The entire line was renamed the Mount Tamalpais and Muir Woods Railway. The new logo on this stock certificate picked up nicely on Double Bow Knot. (Courtesy author.)

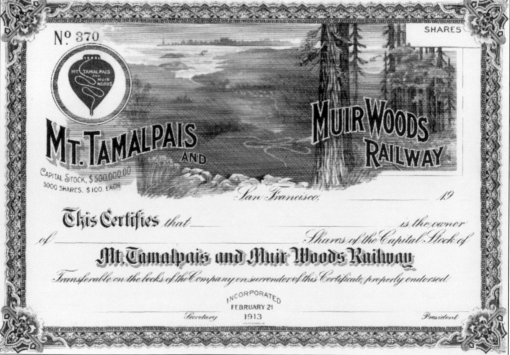

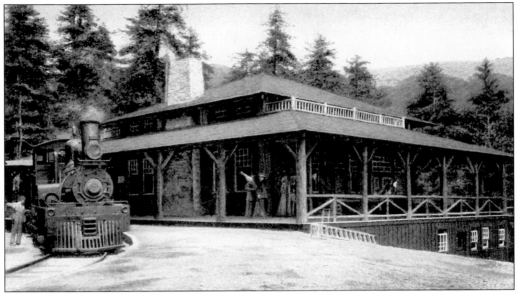

THE MUIR INN. Built in 1908 in a sheltered canyon, Muir Inn was a first-class hostelry set in the rustic beauty of the redwood grove. It offered excellent dining, rest, and recreation a mere two hour's ride from San Francisco. Rooms started at $1.50 a night. (Courtesy author.)

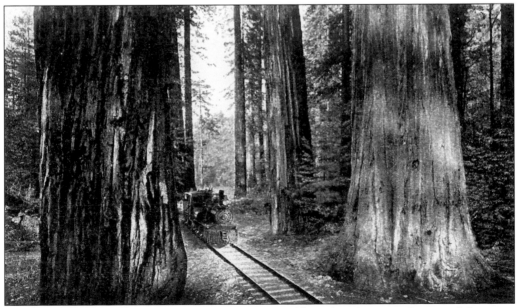

TOWERING GIANTS. After showcasing mountain and bay, the train now showcased the giant redwoods. Brochures called the Muir Woods groves of coast redwoods "God's first temples," pointing out that they were standing when Rome fell. Taller than the Statue of Liberty, mature redwoods defy gravity by siphoning groundwater hundreds of feet up through their trunks. Still, no matter how grand they are, the artist who drew the locomotive into this scenery grossly overestimated the scale of the giant trees. (Courtesy author.)

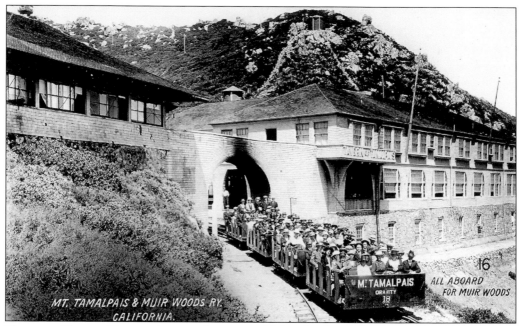

Heading Down. The gravity cars that coasted 2.5 miles down the mountain to Muir Woods soon became one of the most popular features of the "Trip of the Thousand Wonders." Faster than steam-powered trains, these rides, dubbed "the longest roller-coaster in the world," only went to Muir Woods, since the grade into Mill Valley was too gentle. (Courtesy Jim Staley.)

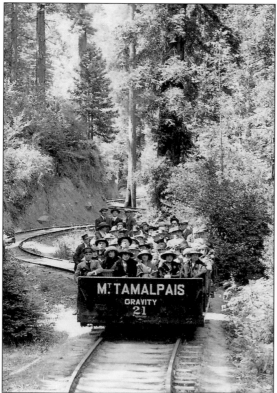

"A Safe and Frolicsome Adventure." Typical gravity cars carried 29 passengers on six rows of wooden seats. The brakeman sat in front, and applied the strong double brakes to regulate the descent. The car's maximum speed was 12 miles per hour. Car No. 9 was restored and permanently installed in a corner of Old Mill Park when Gary Lion was mayor. (Courtesy author.)

Four

RANCHO TO TOWN

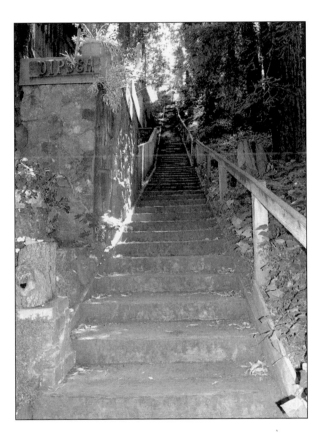

In August 1844, businessman Samuel Throckmorton took over Capt. William Richardson's mortgaged Rancho Saucelito with the promise that the businessman would return a fifth of the ranch free of debts within three years. When Richardson died eight months later, Throckmorton, claiming overwhelming debt, settled with Richardson's heirs for $5,000 each, and kept much of the property.

Throckmorton was proud and fond of his ranch, but it became a financial drain for him too, due to the battles he waged to protect the land from legal claims, as well as from squatters, poachers, and cattle rustlers. The dairies did not produce enough income to offset these expenses. He—like Richardson—had to mortgage the rancho. Upon his death in May 1889, his only surviving heir, his daughter Suzanna, who was by then 40 years old, was forced to settle the $100,000 debt by deeding 3,790 acres, including Cascade Canyon, to the bank that held the mortgage.

By 1890, most of Richardson's former property on the Mill Valley side was subdivided and sold at a public auction. The development was named after Joseph Eastland, president of the company created by the bank to develop the property. The new town site stretched over Richardson's part of the grant only, west of Corte Madera Creek (basically today's Miller Avenue). Where there had been two ranchos, there were now two sections of town developing at different speeds, the new Eastland subdivision to the west, the original Mill Valley area, with only a dozen homes, to the east. For 12 years, the young town was caught up in a controversy over its name: Eastland or Mill Valley?

Mill Valley slowly started its transition from a rancho into an actual town. There were still thickly wooded areas in the present downtown, and bear sightings were not uncommon. Creeks meandered through freely and the salt marshes reached up to present-day Tamalpais High School, past today's Safeway into the Locust area. But homes were now being built, about half of them as permanent residences. These early decades provided the groundwork for the future appearance and character of the town.

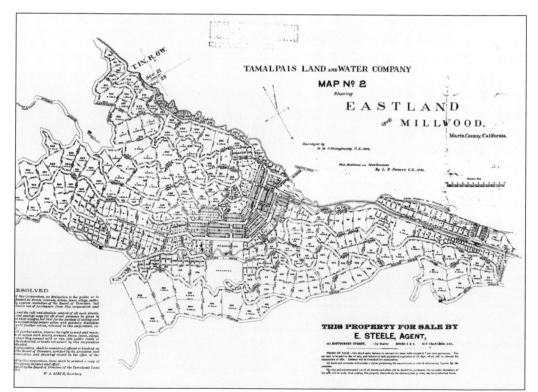

EASTLAND'S END. After Joseph Eastland's death in 1894, the name Eastland fell into disuse. "Mill Valley" prevailed in 1900 when the town was incorporated, and again in 1904, when the post office officially stopped using Eastland. Quite a few of the new avenues shown on the official subdivision map below were named for officers of the newly-created Tamalpais Land and Water Company, like Lovell and Magee. Most streets in the new development were called "Avenue" except for the very short ones like Eugene and Cornwall Streets. (Courtesy MVLHR.)

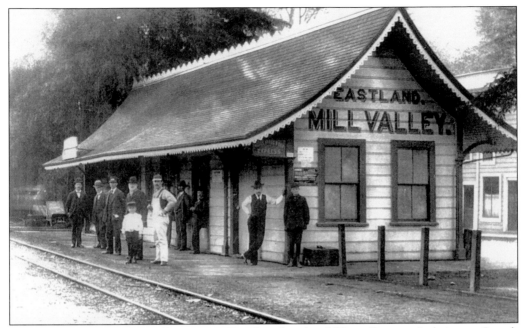

THE NORTH PACIFIC COAST RAILROAD. Tamalpais Land and Water Company's chairman, Joseph Eastland, had extensive railroad company holdings. He arranged for a North Pacific Coast railroad spur to branch off into Mill Valley. The first train reached the new downtown station in October 1889. Since there was no turntable, trains ran backward and forward between the Depot and the Almonte station. Chinese laborers helped build the tracks and were housed in tents east of today's Plaza. (Courtesy MVLHR.)

LOVELL WHITE. Although Joseph Eastland was the moving force in founding the subdivision named for him, Lovell White became the TL&W Company's most influential representative, since Eastland died only a few years after the initial auction. The New Hampshire native came to California with his wife, Laura, in 1859, first to the California gold district, then to San Francisco, where he worked with the San Francisco Savings Union, later succeeding Eastland as president of the TL&W Company. (Courtesy MVLHR.)

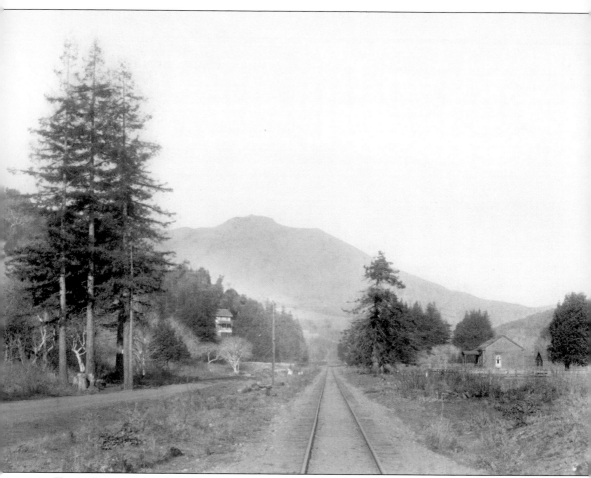

TRAIN RIDE INTO MILL VALLEY. In 1889, the North Pacific Coast Railroad engineer who surveyed the new spur into Mill Valley observed that he saw "no houses, no roads, no men, no women." The Finns' house is the only visible residence in this very early photograph of Miller Avenue. This was the view Mill Valley offered prospective buyers as they rode the train into town for the Memorial Day auction of 1890. Trains stations explain Mill Valley place names, such as Tam Junction, Millwood, and Manzanita. (Courtesy MVLHR.)

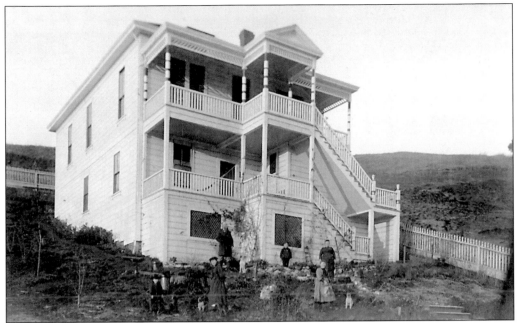

THE MAPLES. When Throckmorton's land was subdivided, his ranch superintendent, Jacob Gardner, left the Homestead lodge and settled with his family at the Maples, a two-story home he erected at Miller and Locust Avenues in 1889. It was named for the native maples on the site. (Courtesy MVLHR.)

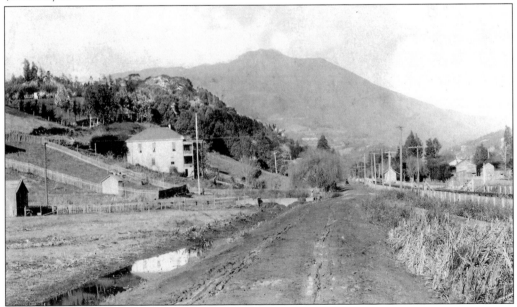

MILLER AVENUE, C. 1900. The TL&W Company encouraged Jacob Gardner to build his house in a visible location to serve as a model of the beautiful homes that could be built around town. His daughter Lillian remembered as a child watching many people passing on Miller Avenue, the main road into town. She recalled hearing announcements on the Millwood train station loudspeaker, the floods that covered the tracks every winter, and the salmon runs when neighbors speared fish in the nearby creek. (Courtesy MVLHR.)

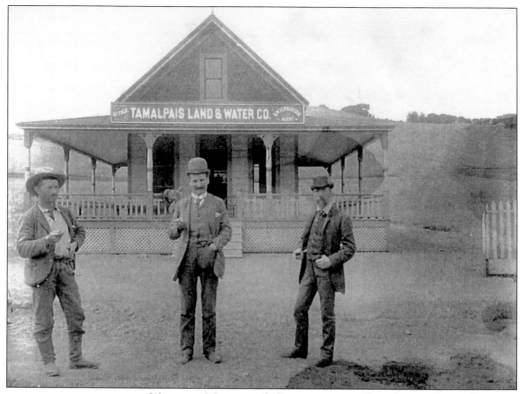

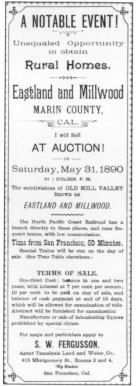

MICHAEL MAURICE O'SHAUGHNESSY. Shaughnessy (center) was in charge of the survey party that laid out the new subdivision for the May 1890 auction. The engineering graduate from the Royal University of Dublin, Ireland, was best known for Hetch Hetchy Dam and San Francisco's Twin Peaks tunnel. His excellent plan featured buggy roads; lots for churches, schools, and parks; and a web of footpaths and stairways. The TL&W Company's Throckmorton Avenue office, shown here, was intended to look like a house. (Courtesy MVLHR.)

MEMORIAL DAY AUCTION. The first auction of lots for the new town of Eastland was organized with great care. It was held on Memorial Day 1890, at the crumbling Old Mill which was dedicated as a public park on that occasion. The new railroad spur brought 3,000 prospective buyers attracted by extensive ads in San Francisco newspapers. On that day alone, 200 lots sold for a total of $300,000. (Courtesy MVLHR.)

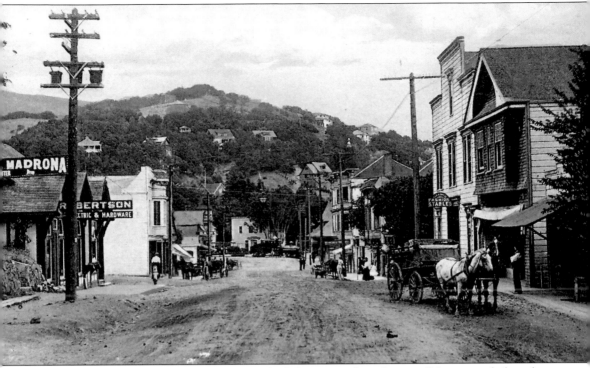

EARLY MILL VALLEY. Local newspapers described the town in lyrical terms: "No spot so sheltered, so exquisitely adorned by nature, and so thoroughly inviting can be found anywhere else in the same distance from the city. The lovely valley is clothed with handsome forest trees, and a charming, never-failing stream of pure cold water runs through it. A more inviting place for a cottage retreat would be hard to find." Yet there was much to do to turn Mill Valley into a town, as this early 1900 view, taken from above the Madrona intersection, reveals. The roads were unpaved for many years and it was Marshall Staples's duty to sprinkle the main thoroughfares with oil to eliminate the dust in early summer. He would then cover it with broken shale or ashes to keep it from being too sticky (see p. 126). (Courtesy Jim Staley.)

THE CITY OF 10,000 STEPS. O'Shaughnessy's web of connecting steps, lanes, and pathways remains one of Mill Valley's uniquely charming features. This extensive, practical network of public pathways connects parallel hillside streets to each other and to the canyon floors all the way to the center of town, providing safe shortcuts and excellent walking routes while lending the town a sense of mystery. A "Step by Step" association is presently restoring these old pathways. (Courtesy Jim Staley.)

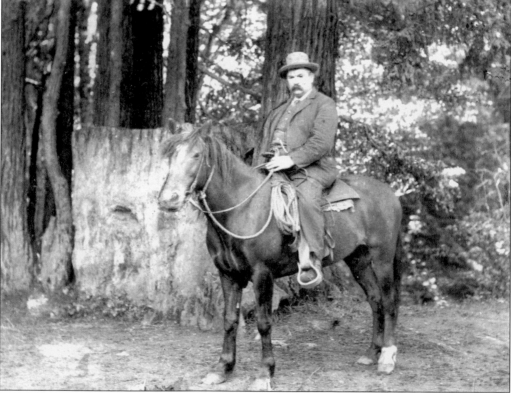

CONSTABLE McDONALD. According to historian Matthew Stafford, there were 15 to 20 bars in town, serving a population of 900 residents in the early 1900s. Cockfights, chicken shoots, and brawls kept the city's first constable, James H. McDonald, on the alert as he made his rounds of town on a strawberry mare. (Courtesy MVLHR.)

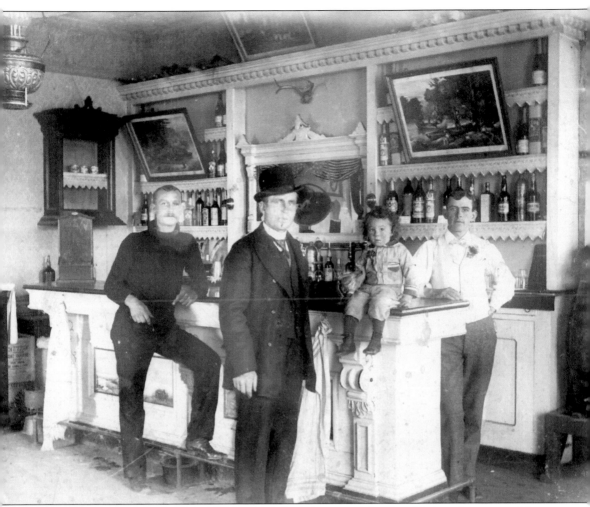

JAGTOWN'S SALOONS. In an effort to appeal to "inhabitants of the class likely to be attracted by the absence of saloons and bars," all deeds and contracts with the TL&W Company contained a clause prohibiting the manufacture and sale of intoxicating liquors, and no saloons were allowed within a quarter mile of the railroad depot. Inevitably therefore, saloons sprang up right outside the company decreed dry zone in an area that became known as Jagtown, between Hill and Dell Streets, off Sunnyside. "Jag" was slang for a drunken spree. Mill Valley's first saloon was located at East Blithedale Avenue and Grove Street. It was known as The Louvre, for the Western art and artifacts that owner Jack Hansen loved to hang on the walls. Hansen (center), shown here in 1901 with his brothers and son Ted, later became a city constable. (Courtesy MVLHR.)

VINEYARD HAVEN. Alonzo Coffin was one of 3,000 potential buyers who attended the 1890 Memorial Day auction. He fell in love with a lot that had a superb view of Alcatraz at 15 Tamalpais Avenue. Here he summered with his wife and daughter until their new home, nicknamed "the Ferryboat House" and visible on the cover photograph, was built in 1893. As Mill Valley's third mayor, Alonzo was responsible for organizing food and medicine lines after the San Francisco earthquake. (Courtesy MVLHR.)

REDWOOD LODGE. George Billings was another of the initial 1890 auction bidders. The native of Cazenovia, New York, purchased four contiguous lots in Cascade Canyon, where he built a shingle-style house called Redwood Lodge. Homes had names rather than numbers then. Cottages and a private tennis court with a split-level grandstand for spectators were later added to the park-like grounds. This old gem still exists, in a quieter setting now that the scenic train no longer runs along its side. (Courtesy MVLHR.)

TREEHAVEN. In 1891, the Thompson family moved to a home they christened Treehaven at Molino and Wildomar Avenues. Fred became the Mill Valley Historical Society's first president, spearheading the effort to save the land adjacent to Old Mill Park from being developed. His sister Kathleen became a much-admired novelist, the most widely read and highest paid woman in the country. One of her 93 novels was entitled *Treehaven*, published in 1932. (Courtesy MVLHR.)

KATHLEEN THOMPSON NORRIS. Kathleen was eleven years old when her family moved to the rural Mill Valley that she described as "one of the exquisite places in the world." Although her novels promoted a conservative view of the American woman, Norris's niece, Helen Thompson Dreyfus, remembered her as a marvelously funny woman, a great raconteuse with a tough, brilliant Irish intellect. A park located at Molino and Wildomar Avenues was dedicated to the novelist in 1946. (Courtesy MVLHR.)

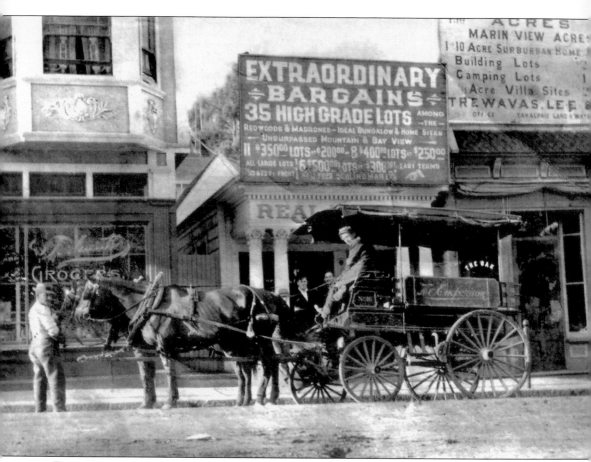

REAL ESTATE ENTREPRENEURS. Speculators bought large tracts of land at the 1890 auction in order to subdivide them later. Only the west side of Corte Madera Creek had been subdivided at the original auction. Developer fever soon spread to the east side of the creek and to property that belonged to homesteaders like Cushing, or John Reed's descendents. Following the Homestead Valley, which was developed by the TL&W Company in 1903, the Blithedale, Sunnyside, Boyle Park, and Sycamore areas emerged as new neighborhoods in the early 1900s. This c. 1908 photograph shows San Francisco's Emporium delivery wagon parked in front of a neoclassical structure built by Harvey Klyce and used as the real estate office of J. Fred Schlingman. An early member of Mill Valley's Masonic Lodge, Schlingman was and one of the most active real estate developers of that decade and was associated with the sale of over half-a dozen Mill Valley tracts. A few streets, like Dot's Lane, Hazel Street, and Rose Street, were named for his family. Schlingman owned the *Mill Valley Record* until 1910, when he moved to Southern California. Another of his flamboyant ad appears on page 75. (Courtesy MVLHR.)

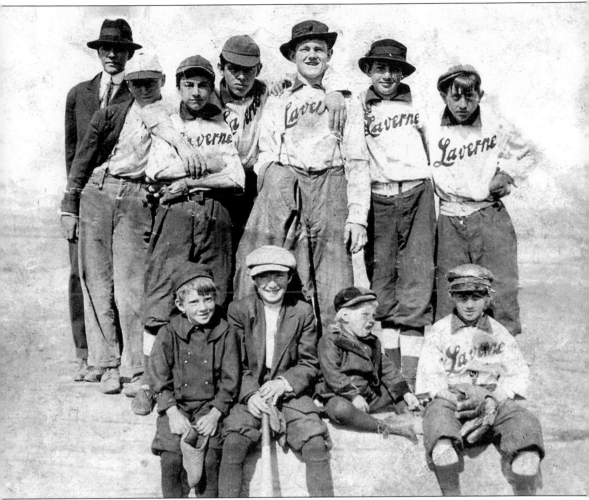

LAVERNE. The TL&W Company began selling lots in Homestead Valley after the marsh that once extended all the way to the Locust area was filled. According to Homestead historian Charles Oldenburg, by 1910 there were 60 homes and a population of 250 in the valley. Jack Kerouac lived there in the 1920s. Homestead's first post office was named Laverne between 1909 and 1914. Pictured here are members of the Laverne baseball team at the turn of the century, before the community's name changed to Mill Valley. (Courtesy MVLHR.)

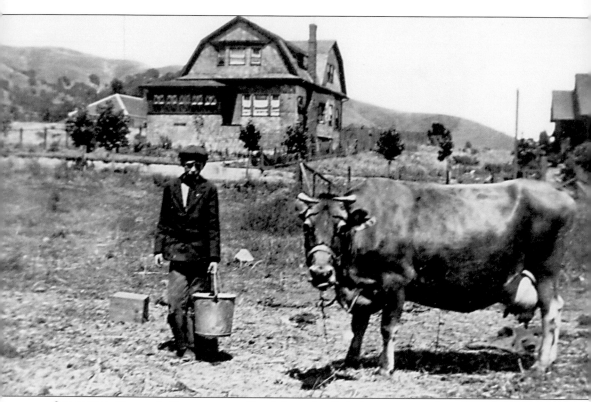

SYCAMORE PARK. A 48-acre tract of land from the E. Judson estate and an additional 60 acres belonging to Mrs. Oliver Sollom, a descendent of the Reed family, were subdivided in the early 1900s. The new neighborhood was designed with curved streets for pleasant horse and buggy drives. Each street was lined with a different tree, like elm, locust, catalpa, walnut, sycamore, or willow and named for that tree. This shingle house at 37 Sycamore was one of the first homes in this attractive neighborhood. The cow in the foreground provided milk to the home's residents. (Courtesy MVLHR.)

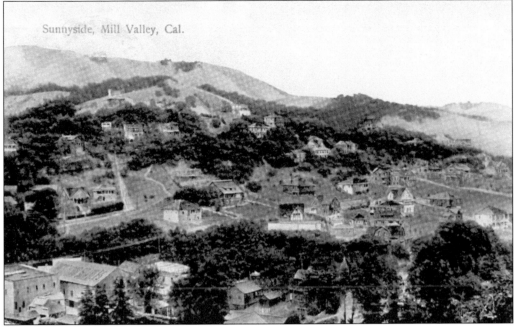

SUNNYSIDE. In the late 1850s, a squatter by the name of Ebenezer Wormouth settled on a section of John Reed's grant that became known as Sunnyside. In 1881, he filed for a homestead on 46 acres of prime Reed rancho land. After Wormouth's death, feuding relatives sold the contested property to developers Lyon and Hoag. (Courtesy Jim Staley.)

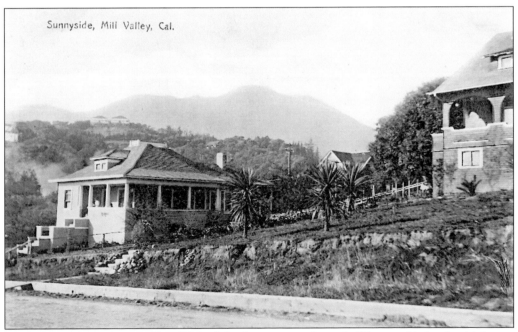

SUNNYSIDE BUNGALOWS. East Blithedale Avenue ran through Wormouth's land, which was subdivided in 1901 as the Sunnyside Tract, with 180 lots selling from between $300 and $700. (Courtesy Jim Staley.)

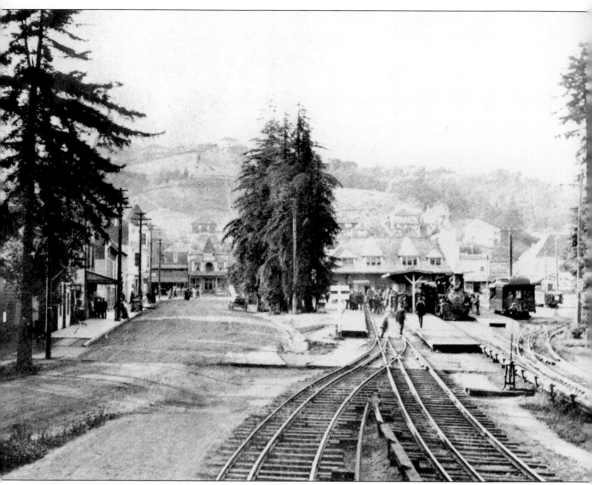

TRAINS. In this turn-of-the-century photograph, the tracks for the regular North Pacific Coast passenger trains commuting from Sausalito are in the foreground, while the scenic mountain trains are at far right. Passengers were able to easily transfer from the commuter to the mountain train. In 1903, North Pacific Coast converted to standard gauge and a third, electrified rail was added. A running fence had to be built along Miller Avenue to prevent electrocution, although many animals paid dearly for a shortcut over the new track. The track layout explains the present-day configuration of the Miller and Sunnyside intersection. The train station stood at the foot of Sunnyside Avenue where it meets Miller Avenue. (Courtesy MVLHR.)

CROSSING THE SQUARE. The mountain train once headed straight across what is now Lytton Square, through an opening between today's Cavallo's and McDonald's, before starting its climb up Mount Tamalpais. This photograph encompasses Mill Valley's major business activities during this period as it shows a dairy, the Marin County Milk Company, next to a real estate agency, and the scenic train's substantial—and many complained "oh, so noisy"— presence in the town's landscape. (Courtesy MVLHR.)

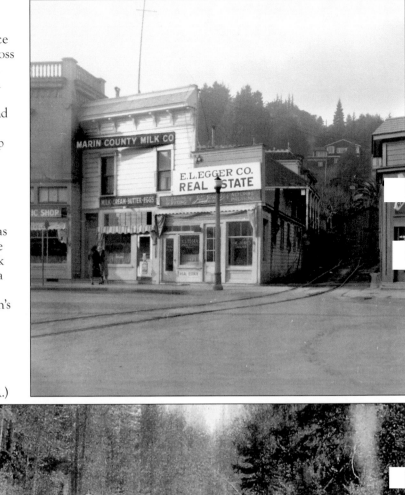

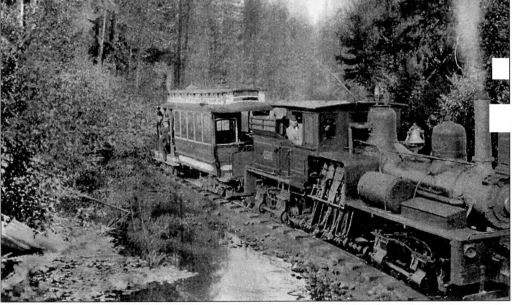

HEADING UP CORTE MADERA CANYON. The mountain train chugged out of downtown and up Corte Madera Canyon, crossing the creek four times in the first mile. After that, it turned and came back around the southern part of the mountain. Some of the cars were like the one shown here, former San Francisco cable cars. (Courtesy author.)

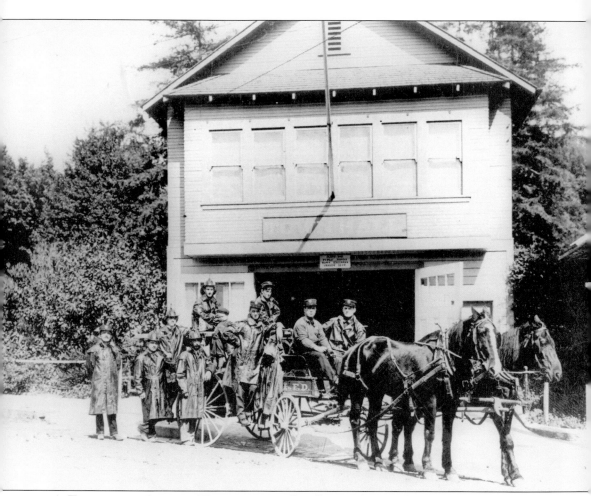

A TOWN WITH ALL THE TRIMMINGS. Mill Valley's volunteer firefighters were, for a while, nothing more than a glorified bucket brigade. They rented their horses from Dowd's Stables, where their equipment was also stored. At the time of this picture in the early 1900s, they had received official status as the Mill Valley Fire Company and their new horse-drawn fire wagon was equipped with hook and ladder. There were only a dozen hydrants in town at that time and water pressure was so low that citizens were asked to turn off their faucets whenever they heard the fire bell. The "laddies" in this picture are Bill Ross, Jean Bedecarrax, Fred Roemer, Tom Bagshaw, Bert Roseveare, Tom's son and mascot Jack Bagshaw, Fred Weir, John Patterson, Dick Lenhart, and Frank Sherman. (Courtesy MVLHR.)

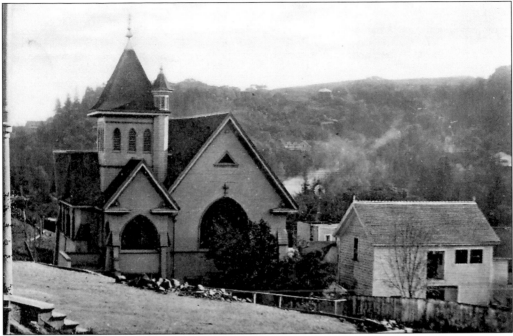

CHURCHES. The Catholic church, built in 1893, was Mill Valley's first house of worship and was originally attended by prominent families like the Reeds and the O'Shaughnessys and by Portuguese dairymen. It became Our Lady of Mount Carmel in 1916. The Episcopal church, built in 1892, at the corner of Lovell and Old Mill Avenues, and the Congregational Church, built in 1896 on Summit Avenue, came soon after. All three churches were built on lots donated by the TL&W Company. (Courtesy Jim Staley.)

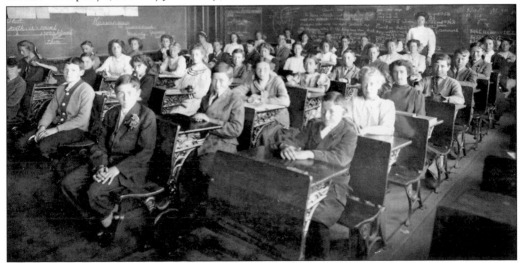

SUMMIT SCHOOL. Mill Valley's first school was built in 1892 on the corner of Summit and Cornelia Avenues, land donated by the TL&W Company. Pioneer settler Jacob Gardner, who had two school-age daughters, played a major role in founding the school, even underwriting the initial school budget. Some of Summit School's very first pupils were, besides Georgina and Leslie Gardner, Walter Coffin (who lived at Vineyard Haven), and Fred, Teresa, and Kathleen Thompson—future novelist Kathleen Norris. (Courtesy MVLHR.)

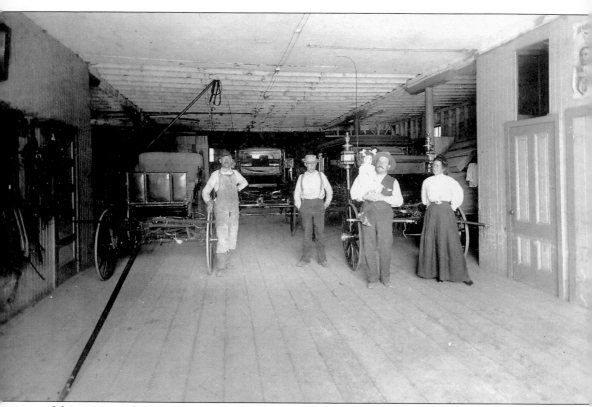

MOVERS AND SHAKERS. In 1891, Charles James Dowd, who grew up on a dairy ranch in Corte Madera, began renting mules and horses to tourists visiting Mount Tamalpais and the Redwood Canyon. Charles built a stable, offices, and living space on Throckmorton Avenue, soon expanding to provide drayage service, since the roads at that time were barely trails. Dowd's Fashion Stables owned more than 100 horses and mules to rent at one time. This early 1900s photograph shows liverymen and Emma Dowd, standing on the right. (Courtesy MVLHR.)

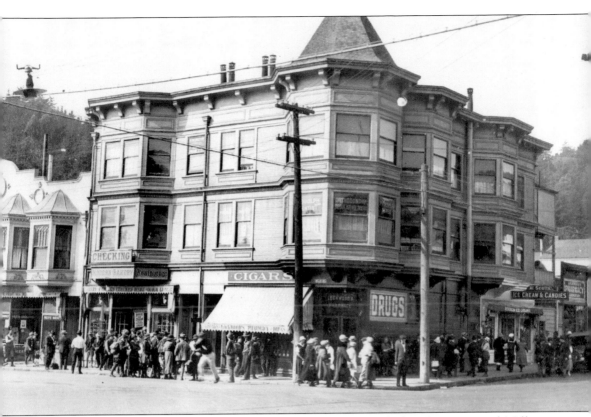

LOCKWOOD'S PHARMACY. This store reigned over the corner of Throckmorton and Miller Avenues from 1906 to 1937, before moving to 12 Miller Avenue. Frank E. Lockwood was the original owner of the business that operated here from 1903 until 1989. In 1960, the pharmacy announced that they had filled 358,000 prescriptions. The owners even published their own line of postcards. (Courtesy MVLHR.)

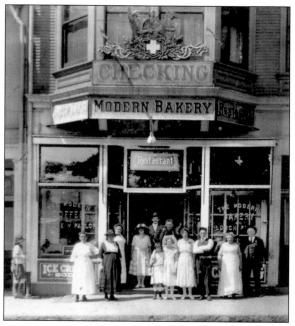

MULLER'S MODERN BAKERY.
This bakery stood at the corner of Throckmorton and Miller Avenues starting in the early 1900s. (Courtesy MVLHR.)

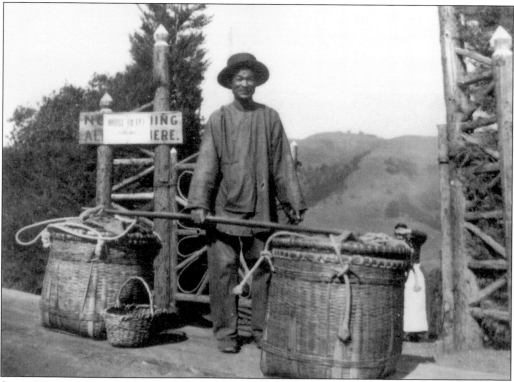

SUEY KEE. A native of Canton, China, Kee probably came to Mill Valley as a laborer for the North Pacific Coast Railroad. He ran a washhouse until 1897, when he started to deliver produce up and down Mill Valley's hills, his heavy baskets hanging from a yoke across his shoulders. He grew much of his produce on leased land, storing shipments in the old China Camp area next to the station. In 1920, Suey Kee went back to Canton a wealthy man. (Courtesy MVLHR.)

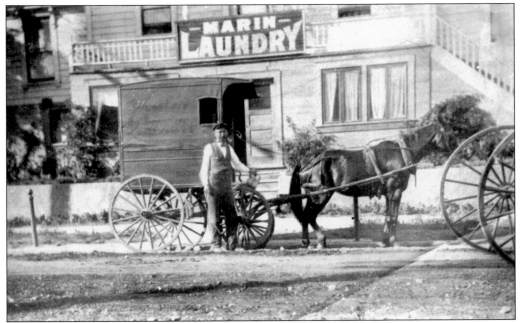

BEDECARRAX'S FRENCH LAUNDRY. This business was a Mill Valley fixture for some 69 years. French Basques Jean and his wife, Josephine, ran their American-French Laundry from 1907 to 1976, first on Miller Avenue, then in their own building on East Blithedale Avenue. Jean served as a volunteer fireman. (Courtesy MVLHR.)

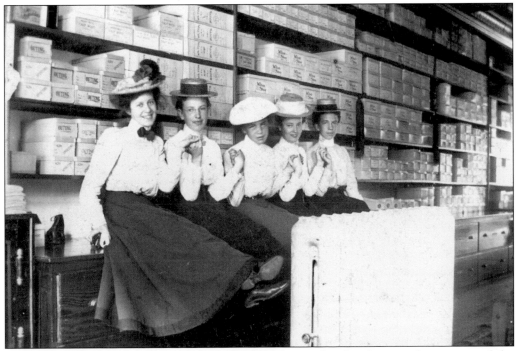

BOOTERY GIRLS. This bevy of young sales girls, posing for the photographer in one of the area's earliest booteries, is quite representative of Mill Valley's small-town atmosphere in 1901. (Courtesy MVLHR.)

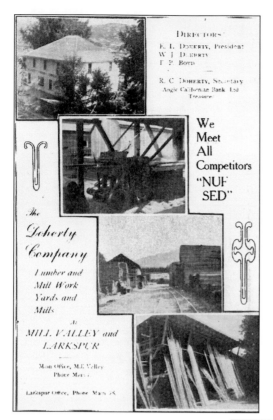

THE BUILDING TRADE. Mill Valley's first lumber company was started in 1891 by Robert Dollar, who built San Rafael's famed Falkirk mansion. There was such a demand for building materials that the local news claimed the company sold lumber faster than they could stock it. The business merged with Doherty's Lumberyard to become the Mill Valley Lumber Company. Some of its buildings, like the old horse stable, are among the oldest in town. A railroad siding came right into the yard, as pictured in this 1907 ad. (Courtesy author.)

HARVEY KLYCE. Tennessee native Harvey A. Klyce studied architecture in San Francisco before moving to Mill Valley with his wife, Caroline Marie, in 1895. He designed and built some 35 Mill Valley homes and served as mayor in 1914. His son Melvin was the contractor on many local projects, including Park School in 1939. Melvin's son Al followed in their footsteps as a third generation architect and contractor. Harvey Klyce, picture here, was a founder of Mill Valley's Masonic Lodge, which recently celebrated its 100th anniversary. (Courtesy H. Klyce.)

THE OUTDOOR ART CLUB. Vandalism was not uncommon in early Mill Valley. In 1902, a group of prominent Mill Valley women, among them Lovell White's wife, Laura, decided to form a woman's improvement club "to preserve the natural scenery of the town and the surrounding country, to beautify the grounds around the public buildings, to endeavor to create public sentiment against wanton destruction of birds, game, as well as to encourage in what is known as civic, social and literary work." (Courtesy MVLHR.)

MAYBECK'S DESIGN. The new association hired famed architect Bernard Maybeck to design a building in keeping with their philosophy. Maybeck's distinctive use of redwood and local stone with a post-and-lintel frame turned the building into one of Mill Valley's beloved architectural gems. The Club was, like Reed's Old Mill, designated a California Registered Historical Landmark. A patio designed in the 1960s by Royston, Hanamoto, and Abbey further enhanced the native plants garden. (Courtesy Jim Staley.)

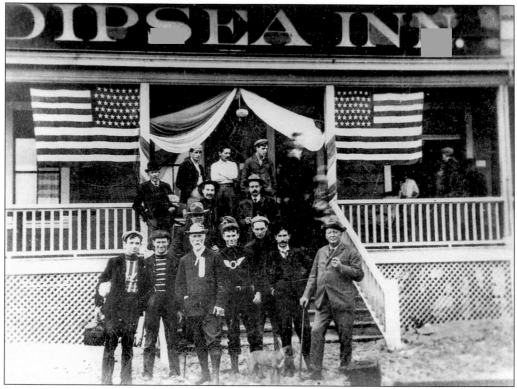

THE DIPSEA INDIANS' RACE. In 1904, a small band of hikers from San Francisco's Olympic Club organized a group called the Dipsea Indians, after an inn built by the Kents on the Stinson Beach sand spit. Two Dipsea Indians raced from Mill Valley to the inn, following the Lone Tree Trail, probably established by the Coast Miwok. Thus began a celebrated tradition from 1905 to this day, now the second oldest cross-country race in the United States, after the Boston Marathon. (Courtesy MVLHR.)

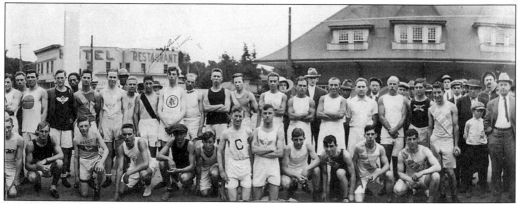

THE DIPSEA RACE. The Dipsea follows a unique seven-mile course with a very tough set of hills and ravines. Its infamous 671 steps up the mountain prompted author and participant Jack Kirk to quip, "Old Dipsea runners never die. They just reach the 672nd step." The 1905 race captured the public's fancy, making front page news in all major San Francisco newspapers. Double the expected runners, 111, signed up, including Oakland teenager John Hassard, who won the race in 1:12:45. (Courtesy MVLHR.)

Five

BUILDING MILL VALLEY

On the eve of the 1906 earthquake and fire, Mill Valley was a small town of about 1,000 permanent residents and another 1,000 summer vacationers. It had planked sidewalks and unpaved roads that turned to dust in the summer and mud in the winter. It now had a city government, its own newspaper, and a train station, and it was again known as Mill Valley. A few small subdivisions slowly encroached on its extensive dairy ranches, but agriculture remained very much a part of the town's landscape.

Mill Valley's popularity as a weekend and summer resort continued to grow, with construction of new inns on the mountain, and William Kent's purchase of the much-loved Redwood Canyon, renamed Muir Woods. A new spur of the Mount Tamalpais and Muir Woods Railway made the giant trees accessible to all. The inauguration of the Dipsea Race, hailed as the greatest cross-country run ever, enhanced the town's successful use of its exceedingly beautiful environment while guarding it from destruction.

The new town was struggling with progress in the form of the "horseless carriage," as some called the automobile, which had all of Marin in an uproar. An *Independent Journal* headline

asked point blank: "Shall the automobile be excluded from Marin?" The danger, annoyance, and anxiety the newfangled machine created, and Mill Valley's bucolic, winding, alternately muddy and dusty roads were cited as evidence that autos should indeed be barred. Progress also brought the telephone, gas and electric power, the radio, and motion pictures.

The little town now faced two decades marked by a host of natural disasters, from the two blazes that raged on the mountain in 1913 and 1923, to severe floods and record snowfalls, and the 1929 inferno that nearly destroyed the whole town.

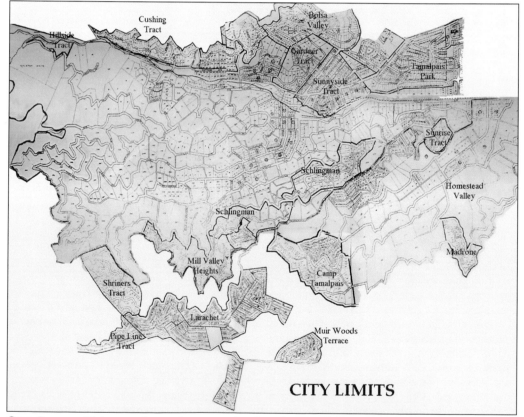

CITY LIMITS. This map shows the tracts developed up to 1923 on both sides of Corte Madera Creek. Unlike 1940s subdivisions, these included lots only, with buyers building their own homes. (Courtesy MVLHR.)

EARTHQUAKE REFUGEES. Only one Mill Valley home, 148 Miller Avenue, was destroyed by the 1906 earthquake, but the disaster left many San Franciscans homeless and anxious to leave the city for safer shores. The Fishers, pictured here, found shelter in Mill Valley following the destruction of their San Francisco home and lived in this tent during the construction of their new home at 342 West Blithedale Avenue. (Courtesy MVLHR.)

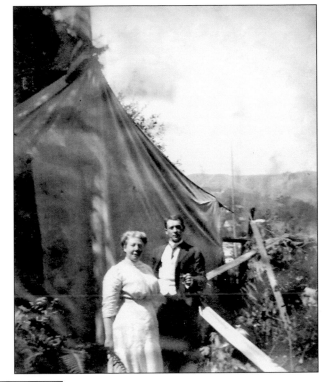

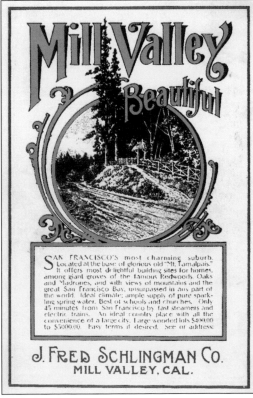

BUILDING BOOM. An accelerated demand for property in Marin County followed the 1906 earthquake. Away from wind and fog—and tall buildings that might fall in an earthquake—Mill Valley's hills, often admired from atop Mount Tam, offered spectacular building sites with magnificent views of mountains and bay, and "all this within a short hour's ferry ride of the highest-waged city in the world, a regenerated San Francisco where work abounds for all," proclaims this 1907 promotional brochure. (Courtesy author.)

75

CAMP TAMALPAIS. A campground with a natural swimming pool and an outdoor fireplace for cooking opened around 1910 in Homestead Valley, between Sequoia Valley Road, LaVerne and Montford Avenues, and Homestead Boulevard. According to historian Charles Oldenburg, small, half-size lots sold for $75, with a tent platform, tent, and folding cot provided for an extra $23. The Depression put an end to this resort. Small cottages then replaced the tents, and lots were combined for standard homes. (Courtesy MVLHR.)

WINFRED VALENTINE STOLTE. This native of Oregon was an early resident of pastoral Homestead Valley. Stolte was working for the *San Francisco Examiner* in 1905, when he fell in love with the valley where he built a summer cottage. He and his wife, Ann, moved in permanently after the San Francisco earthquake. Stolte enjoyed country life, and kept a cow and chickens. A land swap brought him Stolte grove, his legacy to the town of Mill Valley. (Courtesy MVLHR.)

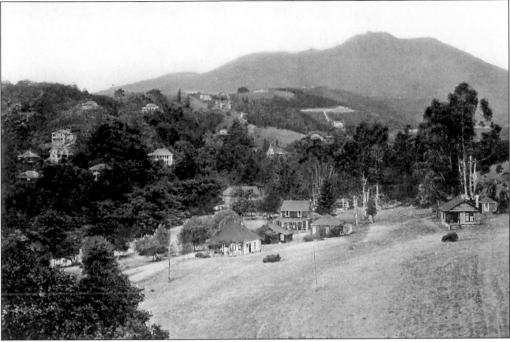

BLITHEDALE CANYON. Blithedale Canyon had already been partially subdivided in 1894, 1903, and 1905, but when Sydney Cushing passed away in 1910, the classy, old hotel was closed, then razed in 1912, and the entire property subdivided into 70 lots. Cottage Avenue was named for the cottages on the hotel grounds. Cushing Drive was named for Dr. John Cushing, Marion Avenue for his daughter, Eldridge Avenue for his wife's family. (Courtesy Jim Staley.)

SELLING PARADISE. A 1912 advertising brochure boasted that roads, sewers, water mains, and utilities were ready to provide services in Blithedale Canyon. The lovely, pastoral subdivision was only a few minutes' walk from the train station and the Mill Valley Post Office. As many as 20 local trains left Mill Valley daily at that time. (Courtesy MVLHR.)

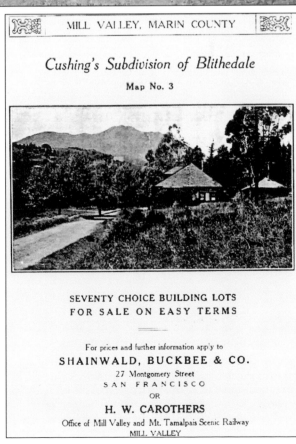

MILL VALLEY, MARIN COUNTY

Cushing's Subdivision of Blithedale

Map No. 3

SEVENTY CHOICE BUILDING LOTS
FOR SALE ON EASY TERMS

For prices and further information apply to
SHAINWALD, BUCKBEE & CO.
27 Montgomery Street
SAN FRANCISCO
OR
H. W. CAROTHERS
Office of Mill Valley and Mt. Tamalpais Scenic Railway
MILL VALLEY

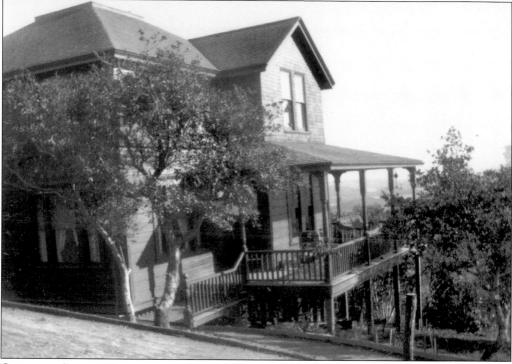

GARDNER, SUNNY HEIGHTS, AND BOLSA TRACTS. Early pioneer Jacob Gardner subdivided the Gardner tract in 1895. His son-in-law, John Burt, subdivided Sunny Heights in 1906. By 1909, they joined forces to subdivide 43 acres purchased from Sidney Cushing's sister. This 1910 photograph shows Cora and John Burt's house at 160 Hillside Avenue, where Burt kept a precious find—the millstones John Reed bartered from the Russians in the 1830s. The family later donated the millstone to the Outdoor Art Club. (Courtesy MVLHR, Gene Stocking.)

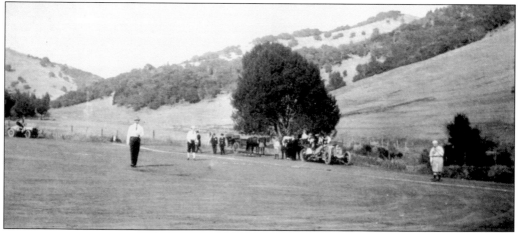

BOYLE PARK. In January 1906, shortly before she died from wounds suffered during the San Francisco earthquake, Carmelita Garcia Boyle had 30 acres surveyed and subdivided, reserving two of the most beautiful for a city park. With its great oaks and meandering stream, Boyle Park preserves a fragment of the original beauty of the land, so loved by Reed's family. Nearby Hilarita and Carmelita Streets were named for Hilaria's daughter, Matilda for Maria Inez's. Baseball started at the park in 1908. (Courtesy MVLHR.)

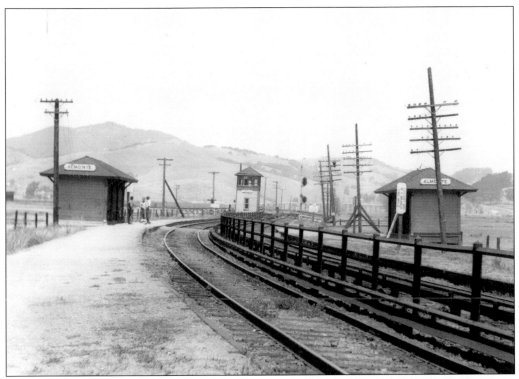

ALMONTE. The name means "to the mountain," and, in fact, there is direct access to Mount Tamalpais and Muir Woods from the Almonte ridge. In 1912, it became the new name of the train station originally called Mill Valley Junction, where passengers could switch from the main Northwestern Pacific line to the Mill Valley line. Cows from the Degnan dairy ranch (just above Graham's Garage) grazed all through this area, much of which was owned by Ernest Jackson at the turn of the 20th century. (Courtesy MVLHR.)

MARIN HEIGHTS. In 1914, a man named Cleveland Dam subdivided his land as a new development called Marin Heights. His name is remembered with Cleveland Avenue, his wife, Rose, in Rosemont Avenue. The lots were narrow and some of the smaller ones were reportedly offered for $5 each as a *San Francisco Examiner* newspaper subscription bonus. Pairs of neoclassical urns left over from the 1915 World's Fair Exposition were placed at the entrance to Stadium and Rosemont Avenues. (Courtesy author.)

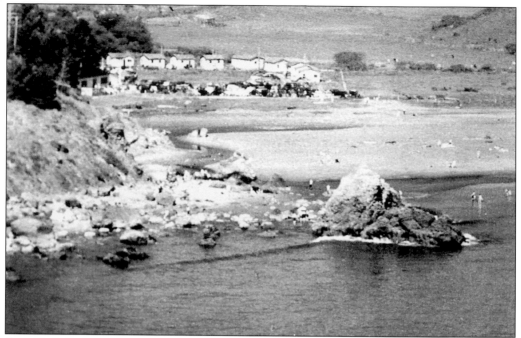

GATEWAY TO MUIR BEACH. The automobile made beaches more accessible from Mill Valley. Autos began negotiating the windy Muir Woods Road in 1908, and in 1916, Highway 1 was extended from Tam Junction to the ocean. Bello Beach, subdivided in 1923, took the name Muir Beach for promotional reasons. Only a dozen houses had been built by 1930. As with Almonte, legend holds that small 35 by 100 foot lots came free with subscriptions to the *San Francisco Examiner.* (Courtesy Jim Staley.)

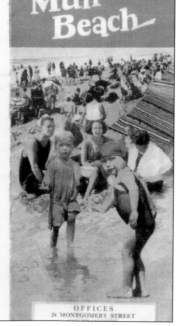

MARIN COUNTY, CAL.

MARIN COUNTY

Muir Beach

HORSEBACK RIDING

Miles of mountain trails for horseback riding and hiking. Marin County is a paradise for motorists, hikers, golfers and all sports.

DANCING

Dancing is enjoyed every evening in the Pavilion.

SWIMMING

A large Fresh Water Lagoon, fed by the waters of Muir Creek, makes an ideal place for the kiddies to play and is perfectly safe.

BOATING

Boating in the fresh water lagoon for the children and canoeing for the adults.

FISHING

Rock Cod, Perch and Sea Trout are to be had in plenty— trolling for Salmon is a special delight.

OFFICES
26 MONTGOMERY STREET

"A COUNTRY HOME AT MUIR BEACH SPELLS HAPPINESS." This late-1920s brochure promotes the new community as the nearest "real" beach to San Francisco, which had "Bungalow and Cabin sites fronting on the Pacific Ocean with a view of San Francisco, Cliff House and Palace of the Legion of Honor in the distance." Directions mention only ferries—although a proposed Golden Gate Bridge is shown—with a turn off at Dolan's Lumber Yard (today the Highway 1 turnoff at Tam Junction). (Courtesy Robert Bolger.)

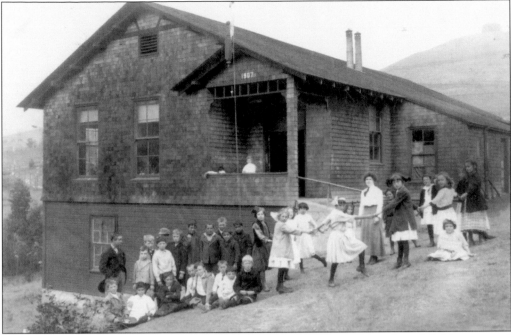

HOMESTEAD SCHOOL. In keeping with the residential boom, a rising number of children created demand for new schools after 1906. Homestead School opened in January 1908, on a half-acre site donated by Lovell White, president of the TL&W Company. It started with 60 children in five grades and was moved to Montford and Melrose Avenues in 1920. (Courtesy MVLHR.)

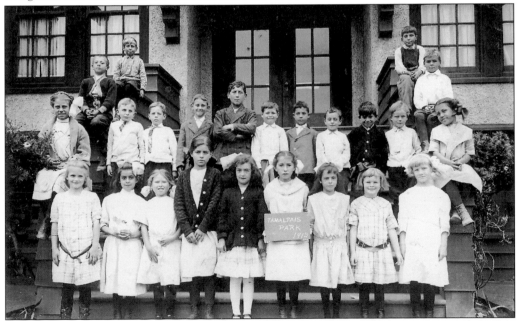

TAMALPAIS PARK SCHOOL. Tamalpais Park was built in 1909 at Catalpa and East Blithedale Avenues, to house the overflow of students from Homestead and Summit schools. It would be greatly expanded in the late 1930s, and gradually became known simply as Park School. This class picture was taken in 1912. (Courtesy Jim Staley.)

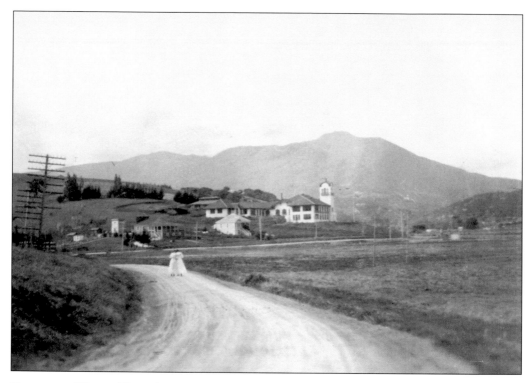

TAMALPAIS UNION HIGH SCHOOL. Because San Rafael High was a city school, Tam High, seen above, was the first Marin County public high school. It was built at the present site, rather than in Sausalito, because the Northwest Pacific Railroad only offered to add a stop at the Mill Valley site. Early morning trains dropped students off at the station in front of the school before classes started at 8:30 a.m. Student labor was used to erect the first gymnasium, according to the principal E. E. Wood's motto: "Learning through doing." Below, Tam High graduates are pictured in 1914. (Courtesy MVLHR.)

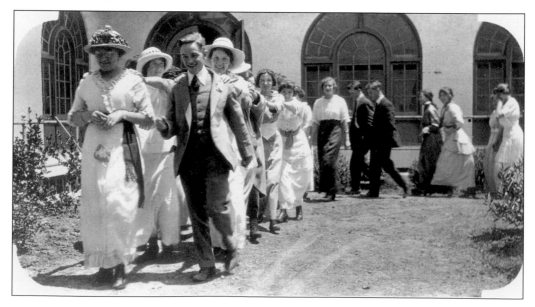

LYTTON PLUMMER BARBER. An outstanding Tam High athlete, Barber was described by his younger brother Roger as a fearless hometown hero, who considered the outdoors his natural habitat. Lytton enlisted at age 17, becoming Mill Valley's first World War I fatality, when he died of meningitis at Fort Lewis, Washington, in December, 1917. Three other Mill Valley residents were killed in the Great War, among them Count Henri de Seine, who died in France leading his troops into battle. (Courtesy MVLHR.)

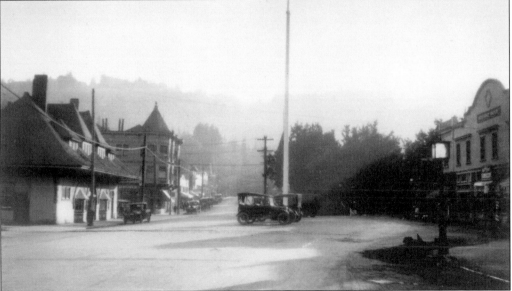

LYTTON SQUARE. Word of armistice came to Mill Valley in the middle of the night as Clarissa Byrne recalled, "The fire department ran around town with the fire engines, whooping and hollering and bell ringing. A woman draped herself nude in an American flag and stood on the fire engine. She was Miss Peace. It shocked the whole town." Belgian Antoine de Vally sang "La Marseillaise" to the crowd gathered in the square, named to honor Lytton Barber. (Courtesy Jim Staley.)

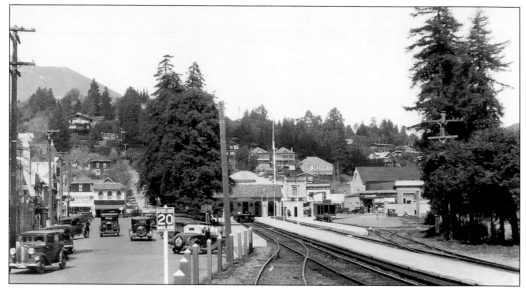

THE GOLDEN 1920s—WORLD OF RAPID CHANGE. Familiar as trains were in Mill Valley, they were now being superseded by automobiles, an increasingly common sight. As the machines replaced horse-drawn vehicles and threatened even the railway, new pressure for better auto roads brought—at last—paved downtown streets in 1917. Compare this view with the picture on page 114. (Courtesy author.)

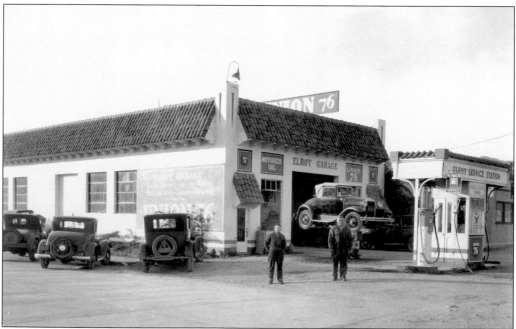

THE ADVENT OF THE GARAGE. Livery stables like Dowd's were completely motorized by the 1920s. In 1929, Frank Filippi's garage opened at the corner of Sycamore Avenue and what used to be the State Highway, today's Camino Alto Avenue. Frank's sons Walter and Robert took over the business 30 years later, and they, in turn, ran it for another 30 years, until 1984. Automobiles were spreading fast. Dowd's, Mill Valley's largest livery stable, was completely motorized by the 1920s. (Courtesy MVLHR.)

DOMESTICATING THE AUTOMOBILE. No one was hurt in this accident, which took place in 1910 with William Kent at the wheel (on the right in this picture), but it confirmed the dire predictions of local newspapers that claimed the roads of Marin County were not designed for the horseless carriage. They also firmly believed that "the automobile in Marin County can never be more than a plaything for a few fortunate individuals who have a surplus of time and money." The first of these "few fortunate individuals" were, besides William Kent, Harvey Klyce in 1906, and Nicholas Yost, who owned the Mill Valley Lumber Company. (Courtesy MVLHR.)

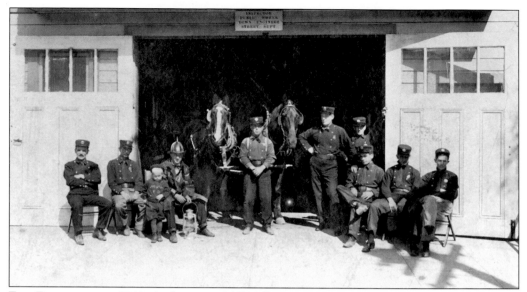

FIRE DEPARTMENT, 1910. At that time, Mill Valley's Fire Department consisted of a horse-drawn hook and ladder wagon, housed at the town hall where the firemen held social functions. A gathering of 100 men was described in a *Mill Valley Record* article, including "music, songs, and stories, and several clever boxing bouts." Shown here, from left to right, are Frank Thompson, Tom Bagshaw and son Jack, Fred Roemer, Dick Lenhart, Franck Sherman, John Patterson, Jean Bedecarrax, Fred Weir, and Bert Roseveare. (Courtesy MVLHR.)

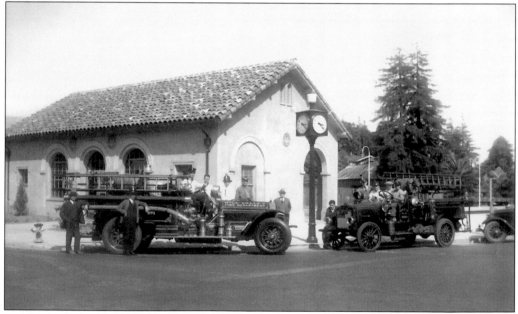

FIRE DEPARTMENT, 1929. Twenty years later, the city's firefighters no longer used Dowd's horses, as they could boast a motor-powered DeMartini truck acquired in 1918, and a top-of-the-line American LaFrance fire truck, purchased in 1925. These are proudly displayed here in front of the clock (at the corner of Lytton square and Miller Avenue) that was donated by the Mill Valley Fire Department in 1929. The train depot building behind them had just reopened and it looked then as it does today. (Courtesy MVLHR.)

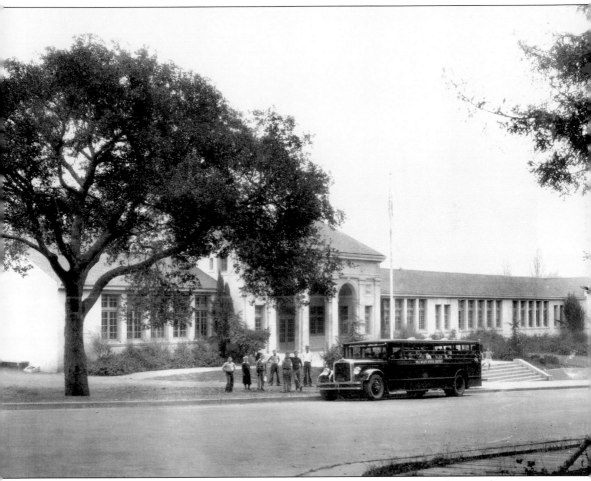

OLD MILL SCHOOL. Even the school district now had wheels. Old Mill School opened in 1921, after the school district bought the 2.5 acre Sulphur Spring site, moved six homes that had been built on it, and paved over the spring —which has occasionally bubbled through the playground's surface since, causing only minor damage. In this picture, taken a few years after the school opened, the sidewalk on the right is still made of wood, but Throckmorton Avenue is finally paved. (Courtesy MVLHR.)

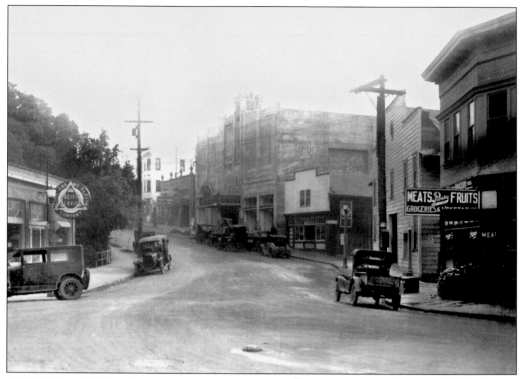

Souvenir Program

Celebrating the Opening of
SEQUOIA THEATRE
Mill Valley, California

Thursday Evening, February Twenty-first
Nineteen Hundred and Twenty-nine

THROCKMORTON AVENUE, 1929. In February 1929, the modern art-deco style Sequoia Theater opened with the promise that it would soon feature the "talking device." The existing Hub Theater that had opened in 1915 with Charlie Chaplin movies, immediately went out of business. The new Sequoia Theater was still unfinished at the time of this photograph, which shows both a livery stable and a new Studebaker auto dealer on the right side of the street. (Courtesy Jim Staley.)

GRAND OPENING. Described as a first-class theater, the Sequoia had a big Wurlitzer organ, and uniformed ushers used flashlights to shepherd customers to 1,200 plush seats. "Ours is the business of making people happy!" enthused the opening night program. "What a privilege to be so engaged! We hope that you will often find yourself within these walls—delighting in the photoplay offerings, our stage presentation and the enchanting music." The Sequoia has hosted the Mill Valley Film Festival since 1977. (Courtesy MVLHR.)

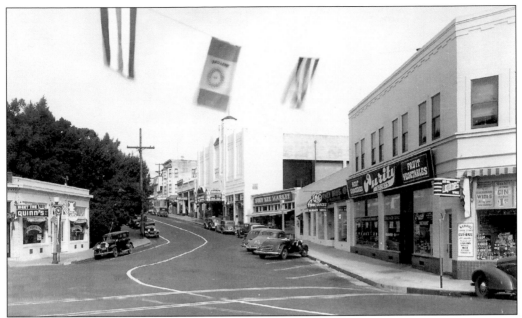

THROCKMORTON AVENUE, 1938. A decade later, the Purity Market has streamlined its window and signs and parking spaces are now painted on the street. Suey Kee's store and Varney's Hardware now sit side by side to the right of the Sequoia Theater. The Studebaker store was replaced by a drugstore, and a liquor store has started its 65-year rule over the corner in the right foreground. Here the Sequoia features Errol Flynn in *The Adventures of Robin Hood*. (Courtesy author.)

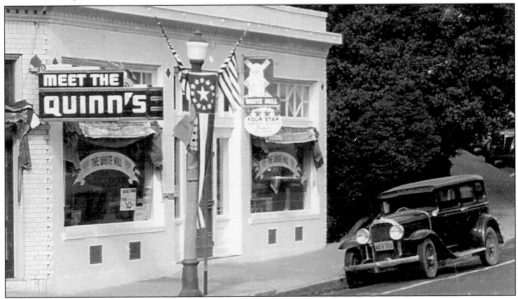

PROHIBITION YEARS. In 1929, James Francis brought his San Francisco South-of-Market-Street savvy and bookie talent with him to a candy store he purchased at the corner of Throckmorton and Corte Madera Avenues in Mill Valley. According to local lore, in the front Quinn sold candy, in the back he sold bootleg whiskey. At one time or another, Quinn owned every bar in Mill Valley. He eventually got rid of all of them except for his namesake saloon, Quinn's. (Courtesy author.)

THE MILL VALLEY BANK. The post-earthquake population increase engendered many new businesses, including Mill Valley's first bank, opened in a half-timbered Tudor-style building erected by Harvey Klyce on Throckmorton Avenue in 1907. In 1911, the Mill Valley Bank (which became the Bank of Italy in 1927 and Bank of America in 1930) moved into the town's first masonry building, also built by Klyce, at Throckmorton and Corte Madera Avenues, a landmark on that corner for almost a century. (Courtesy MVLHR.)

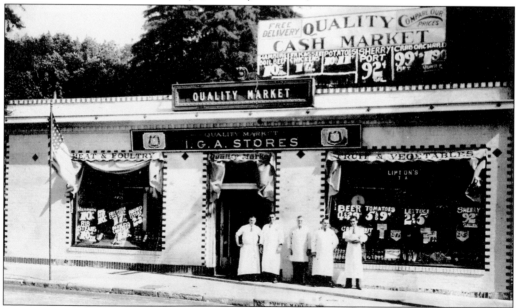

THE QUALITY MARKET. Food-related businesses in Mill Valley thrived in this period, since residents shopped for produce and packaged goods in specialty stores like bakeries, creameries, meat markets, and groceries. A few businesses provided delivery by horse and wagon, later by automobile, and there were mobile grocers like Suey Kee as well. The site once occupied by Quality Market on Corte Madera Avenue, seen above, is today occupied by the Mill Valley Market. (Courtesy MVLHR.)

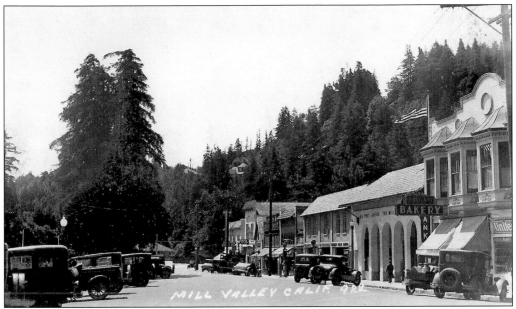

MILLER AVENUE. This 1930s view of Miller Avenue shows a remarkable proliferation of cars within two decades since they first appeared. The block looked much as it does today, except for the post office that was at that time located in the arched building, shown here. It was relocated to the corner of East Blithedale and Sunnyside Avenues in 1941 and now serves as a bank. (Courtesy Jim Staley.)

SUNDAY DRIVES. Novelist Kathleen Norris remembered with trepidation in her book *Noon*, that on Sundays her father took his wife and six children for a 10- to 14-mile walk over the mountain. "Many a time have our twelve- and fifteen-year-old hearts and legs staggered, appalled at the prospect of the last six or seven miles, after a really exhausting scramble," she recalled. The new generation now faced long motorized Sunday drives and engine breakdowns. (Courtesy Suki Hill.)

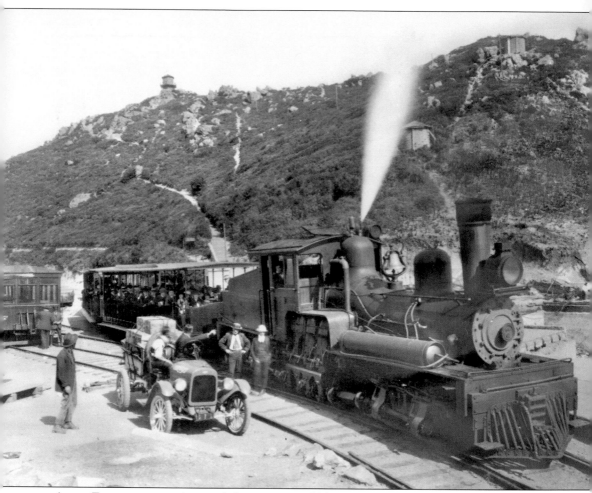

AUTO ENTHUSIASTS. Automobile owners could be seen testing the endurance of their new machines by actually driving over the Mount Tamalpais railroad tracks, which is how this 1920s Chevrolet pickup truck reached the top of the mountain. The railroad's windy route seemed ideal to test drive some of the early models for publicity purposes: "The motor truck never even faltered on its upward flight of eight and a half miles," a 1918 issue of *Motor Magazine* boasted after such a ride, aimed to prove that automobiles could replace the steam engine. Spectacular perhaps, but undoubtedly lacking in comfort. (Courtesy MVLHR.)

SIGHTSEEING IN 1928. To accommodate automobile traffic, new highways were built over old wagon roads, like Ridgecrest Boulevard in 1925 and Panoramic Highway in 1928. Open buses, such as these San Francisco Sightseeing Company trucks recycled from the 1915 Panama-Pacific Exposition and fitted with solid rubber tires, leaf springs, and sturdy radiators, competed with the scenic mountain train to bring tourists to the top of Mount Tamalpais and Muir Woods. (Courtesy MVLHR.)

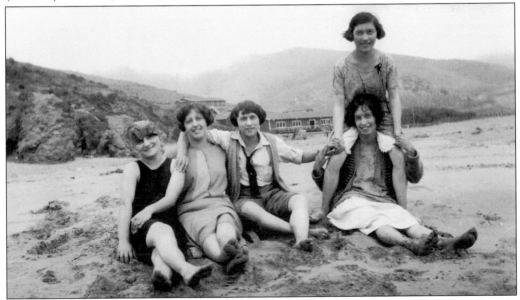

BATHING AT MUIR BEACH. One of the favorite summer outings was a drive or hike to Muir Beach, where vacation cottages were now sprouting. Portuguese settler Antonio Nunez Bello was said to have purchased the entire area from the TL&W Company for a $10 gold piece in 1910. Legend also has it that rum runners had a camp there, which they set on fire when constables closed in on them. Old shell mounds recall the prehistoric presence of Coast Miwok bands along today's Muir Creek. (Courtesy Suki Hill.)

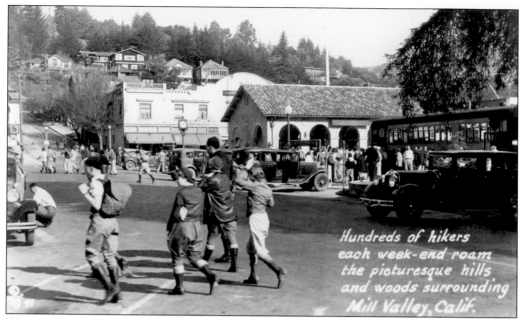

Hundreds of hikers each week-end roam the picturesque hills and woods surrounding Mill Valley, Calif.

WEEKLY INVASION. Despite the automobile craze, hundreds of hikers continued to swarm to Mount Tamalpais's gateway town each weekend "like locusts," locals complained. Streets thronged with excursionists and toughs, and the tinkle of bottles flying off the mountain train was a familiar sound. Full moon walks that sometimes gathered hundreds of hikers were turning rowdy. One resident recalled police running "questionable ladies" out of the roundhouse of the mountain and commuter trains, "where they had been seeking some evening business." (Courtesy author.)

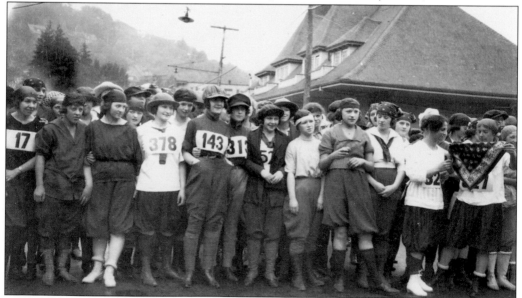

DIPSEA TRAIL HIKE FOR WOMEN. When this picture was taken in the early 1920s, women were not allowed to compete in long distance races. Dipsea Races for women were therefore called hikes. Miss Emma Reiman received a silver cup and a pearl necklace when she won the 1921 event in 1 hour 16 minutes "which is said to be a good time for a man," the *Mill Valley Record* reported, adding that "the race was carried through with commendable dignity." (Courtesy MVLHR.)

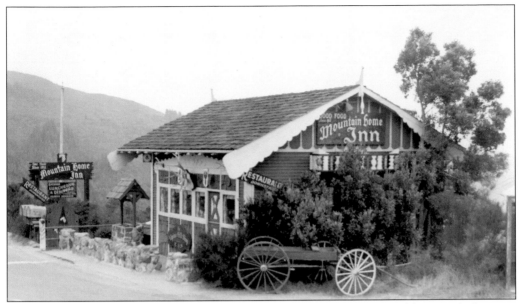

THE MOUNTAIN HOME INN. Swiss nationals Claus and Martha Meyer opened their inn for business in 1912. The sloping pastures of Mount Tamalpais reminded them of their Swiss homeland—as they did Oakland native Jack London, who called Mill Valley "America's Little Switzerland" in his 1901 novel, *The Sea Wolf.* The inn served hearty German dishes fit for famished hikers in a cheerful Bavarian décor, as this 1918 picture shows. It changed hands in 1930, and was completely renovated in 1985. (Courtesy MVLHR.)

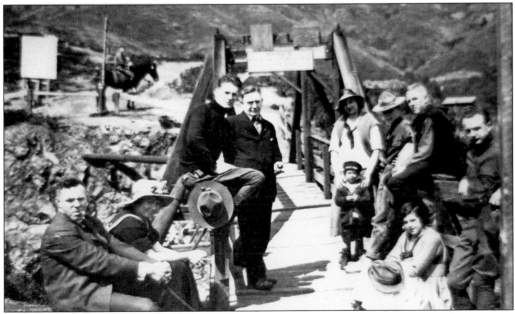

SUNDAY HIKERS. One longtime hiker remembered that on his train and ferry rides back to San Francisco "hikers were made to sit in the rear cars so the refined people wouldn't get their clothes dirty from the dust the hikers brought with them." Each group had its sometimes loud singing club. Women were not allowed to wear pants when hiking until 1920. Sir Arthur Conan Doyle was one of Mount Tam's most famous hikers in 1923. (Courtesy MVLHR.)

MOUNTAIN AMPHITHEATER. This natural amphitheater has been home to the Mountain Play since 1913, and is now a part of Mount Tamalpais State Park. Those born in the shadow of Mount Tamalpais often felt compelled to protect it. The Mount Tamalpais National Park Association was created in 1903 with the intention of purchasing 530 acres of mountain land from private hands, namely the Newland and Magee families of the TL&W Company, and preventing further roads or development. It was not until 1928, after endless court sessions, that the acreage was finally turned into public land. The acquisition of mountain land would continue until today when it encompasses 6,300 acres. While William Kent repeatedly donated large tracts of mountain open space and ridges to the public, others, like his friend Sidney Cushing, wished to see the land shared and enjoyed by all. Cushing helped create the scenic train that opened the mountain to the rest of the world. Others, like botanist Alice Eastwood, found it an object of endless interest. Eastwood dedicated much of her career to the exploration of the mountain's flora. The challenge has always been to strike a balance between protecting and sharing the land. Kent wished to dedicate the mountain theater to his friend Cushing (who had died in 1910) because Cushing "taught me the lesson that this mountain is too good a thing to be reserved in the hands of a few." (Courtesy MVLHR.)

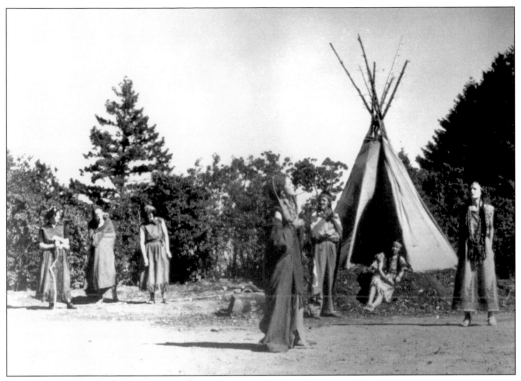

MOUNTAIN PLAY. On May 4, 1913, 1,200 people saw the first mountain play, the brainchild of UC drama instructor Garnet Holme and his student, Ramon Pohli. Its success led Kent to deed the theater to the association on condition that a play be performed there annually for 25 years. Both Holme and Pohli died in a fall in two separate incidents and are memorialized with the amphitheater's Pohli Rock. Writer Dan Totheroh's *Tamalpa* became the theater's most beloved play. (Courtesy MVLHR.)

TAMALPA. In 1920, Garnet Holme asked writer Dan Totheroh to write a play about the mountain. Unable to find an old legend to generate his play, Totheroh made one up. The legend of Tamalpa, the sleeping maiden, was a hit when it was first presented in 1921, and the maiden—forever asleep on its slopes, her body silhouetted against the sky—gave the mountain its most enduring legend and nickname, the Sleeping Maiden. (Courtesy MVLHR.)

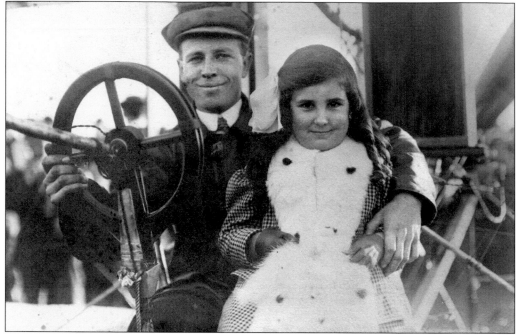

LANDMARK FLIGHT. In 1910, mountain railroad president, C. Runyon, offered $1,000 to the first aviator who could fly his plane from San Francisco around the summit of Mount Tam. In December 1911, 27-year-old Weldon Cook took up the challenge: he flew from the East Bay, circled the mountain, and landed in Mill Valley's Locust area. His feat inspired photographers to etch biplanes on Mount Tam postcards at a time when no camera could capture a moving object. (Courtesy MVLHR.)

ZAN OF TAMALPAIS. One of the best and most prolific postcard photographers from the 1920s to the 1950s was Alexander J. "Zan" Stark, a native of Michigan, who moved to California as a young man, first living in San Francisco before settling in Mill Valley in the mid-1920s. From his studio at 324 Miller Avenue, he produced hundreds of California views under the name Zan of Tamalpais, using a "zf" signature logo, now familiar to postcard collectors. (Courtesy Jim Staley.)

INFERNOS. Fires were common on the mountain. In 1859, a blaze raged on Mount Tamalpais for 3 months. In 1881, another burned an estimated 65,000 acres above Blithedale Canyon. An 1893 fire, started by campers, charred 3,000 acres, and a 1923 county-wide fire swept across 40,000 acres, reducing the Tavern of Tamalpais to ash. Most terrifying of all were the flames, driven by high winds, that swept down Middle Ridge into Blithedale Canyon, heading straight for downtown in 1929. (Courtesy MVLHR.)

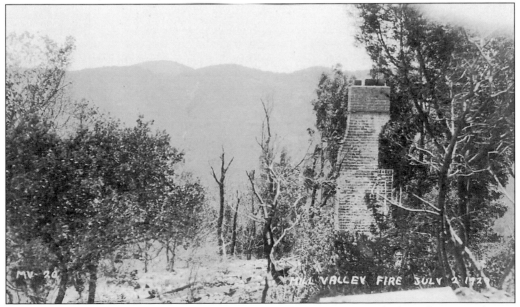

BARELY SAVED. The blaze came within two blocks of the railway station before a fortunate change in the wind veered the path of the flames away from the business district and into Throckmorton Canyon. For three more days, flying cinders greeted ferryboat passengers out on the bay as the fire raged out of control on the mountain. A total of 117 homes were destroyed and over 2,500 acres were burned. City Assessor Falley set the damage at $1.045 million, equivalent to $100 million today. (Courtesy Jim Staley.)

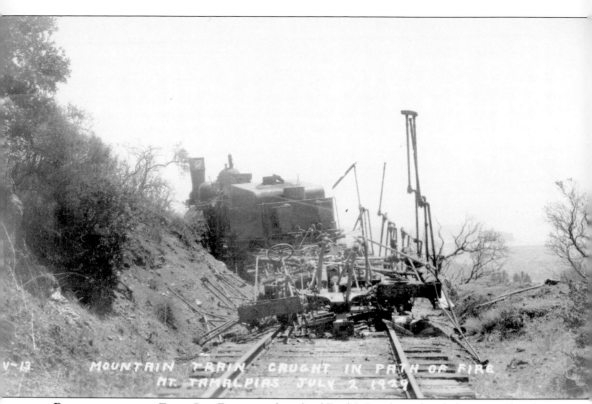

MOUNTAIN TRAIN CAUGHT IN PATH OF FIRE
MT. TAMALPIAS JULY 2 1929

V-13

RIDING THROUGH FIRE. San Francisco fire chief Fred J. Bowlen related the epic ride of T. J. "Jake" Johnson, the veteran railway engineer, who piloted the last train down the mountainside—braving a winding, blazing, smoke-filled inferno, as thousands of rattlesnakes, driven from cover by the flames, made the rails slippery, "necessitating a liberal use of sand to keep the train under control." His passengers, all the while, kept their heads wet with champagne. The scenic train closed that winter and never ran again. In spite of widespread destruction, no lives were lost. (Courtesy MVLHR.)

Six

GROWING UP

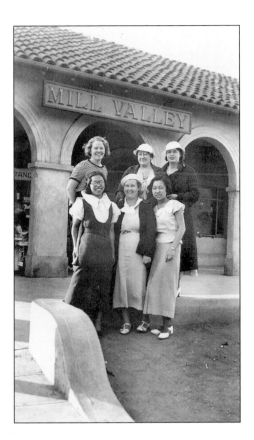

Quietly prosperous Mill Valley emerged from its most destructive fire a changed town: the crookedest railroad shut down operations forever, its rumbling and whistling now a thing of the past. Another disaster closely followed the first. The very last run of Mount Tam's scenic railroad occurred only a few days after the stock market crash of October 1929, and its effect was magnified by the closure of the mountain train and the resulting loss of jobs.

Residents like the O'Roarkes made the best of the situation. Their daughter Florentine remembered that her parents used timbers salvaged from homes destroyed in the 1929 fire to build their home at Muir Wood Park. Mill Valley was reaching maturity as an independent community. Most of its new homes were now being built as permanent residences, and many could boast not only a telephone, but their very own garage. Real estate remained a principle business due to an explosion of growth outside the city limits with Tam Valley, Homestead Valley, Alto, Marin Heights, and Strawberry Point.

The automobile was beginning to dictate the town's evolution and the residents' lives as well, just as the train had in previous decades. Roads were paved, new highways opened, new bridges were under construction. The city's landscape changed as the scenic train tracks were removed,

marshes were filled, the course of creeks altered, and Highway 101 was realigned with Richardson Bay Bridge. These changes spelled doom for the ferry and train system from Sausalito to Mill Valley, but they opened the gateway to Mill Valley, making Mount Tamalpais and Muir Woods more accessible than ever before. While the number of visiting hikers declined, the number of visiting autoists increased dramatically. The town and her citizens now faced two difficult decades filled with the hardships of the Depression and World War II.

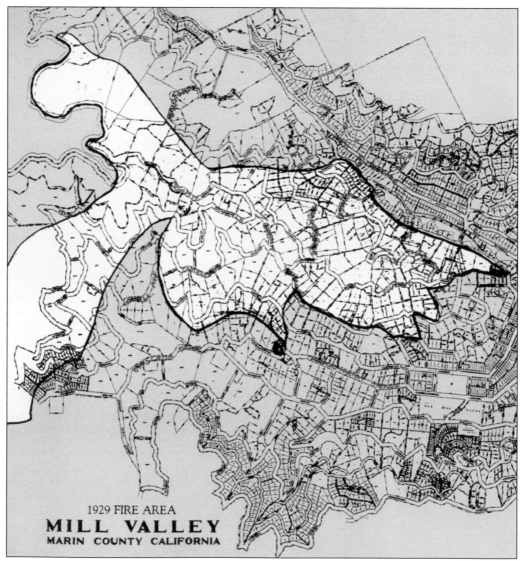

FIRE MAP. About 100 homes were lost, mostly in the vicinity of Summit, Tamalpais, Magee, Marguerite, and Ralston Avenues, and portions of Cascade Canyon. This map outlines the area devastated by the fire of 1929, with the south line ever so close to downtown and Lytton Square, marked as a blank rectangle at bottom right. (Courtesy MVLHR.)

102

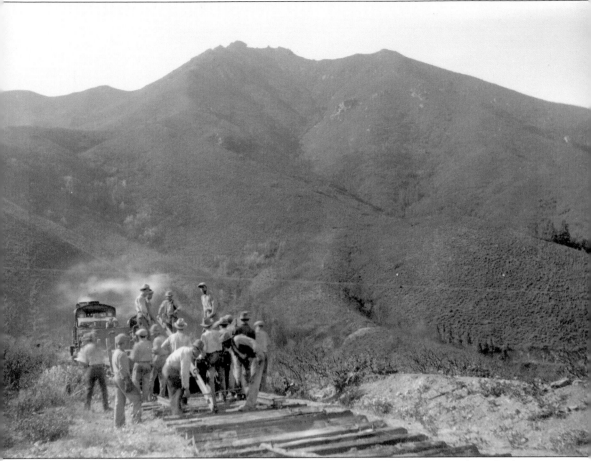

DISMANTLING THE MOUNTAIN TRAIN. The swift increase in automobile touring and new highway construction presented serious competition for the mountain train. The adverse effect of the 1929 fire and stock market crash dealt the mountain train its final blow. In 1930, the Mount Tamalpais and Muir Woods Scenic Railway applied to abandon all of its lines in Marin County. Workmen started tearing up the track. Rails and ties were removed and stacked with all other equipment on the scrapping trains, then taken down. This photograph was shot as the crew worked halfway down the grade from Summit Avenue, with East Peak's outline filling the sky in the background. According to railroad fireman Bill Provines, Mill Valley got so quiet that "if a dog barks twice, they call the cops, now." (Courtesy MVLHR.)

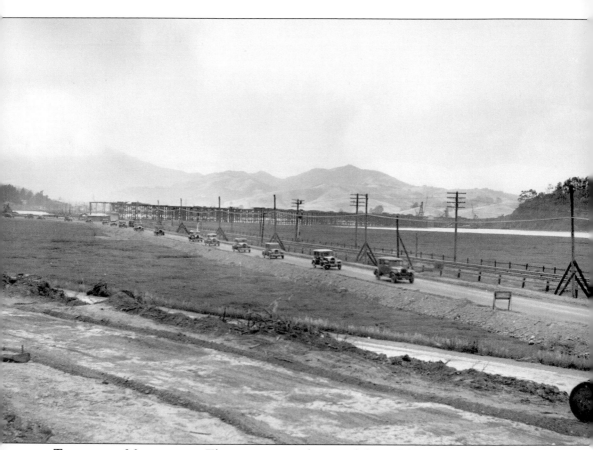

TRAFFIC AT MANZANITA. This procession of automobiles at Manzanita in 1931 was just a forerunner of traffic to come: a new bridge was being built over Richardson Bay that would redirect traffic between Sausalito and Corte Madera, away from Almonte Boulevard and Camino Alto. The extensive, ongoing construction is visible in the background of this photograph. When the Richardson Bay Draw Bridge was inaugurated with great pomp on November 22, 1931, it was the world's longest drawbridge, with a structure made of two million board feet of redwood. The drawbridge itself was only used on a handful of occasions. The bridge as we know it today was built in 1956. (Courtesy MVLHR.)

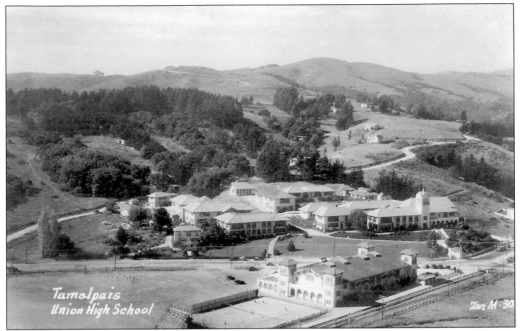

TAMALPAIS UNION HIGH SCHOOL. Until the opening of the Richardson Bay Bridge in 1931, Marin's main Highway cut through the high school campus, seen above in the mid-1930s. The small Northwestern Pacific railroad station is visible on the northeast end of the gymnasium. The train tracks later became Miller Avenue. (Courtesy Jim Staley.)

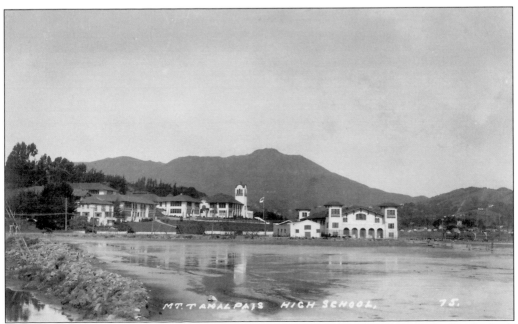

HIGH SCHOOL BY THE BAY. Richardson Bay was once navigable to Tamalpais High school, which was built on the edge of the tidal marsh and arroyo, an area vulnerable to flooding that is now covered by landfill and homes. (Courtesy Jim Staley.)

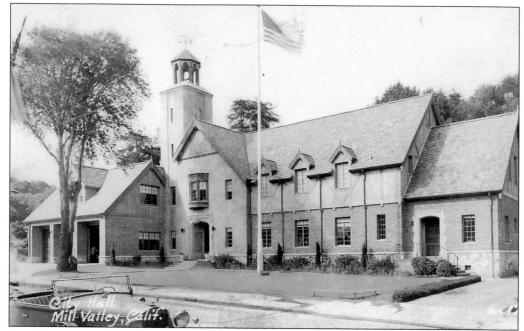

THE DEPRESSION YEARS. The national crisis took its toll on Mill Valley: companies failed, and employees—many working for the now defunct mountain train—were laid off. The Works Progress Administration funded useful projects in and around the city, contributing to the construction of a new building at 26 Corte Madera Avenue, designed to house both city hall and the firehouse. (Courtesy Jim Staley.)

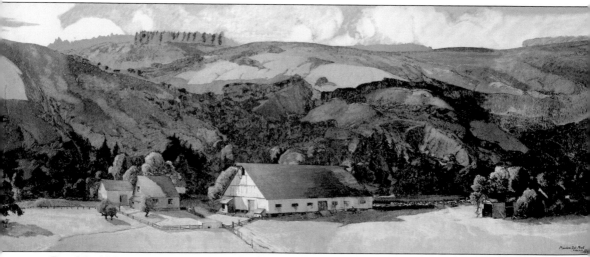

DEL MUÉ MURALS. In 1937, the WPA built a 3,300-seat amphitheater at Tam High. In 1938, the Federal Art Project hired established artist Maurice del Mué to paint a 38- by 8-foot mural for the high school, depicting *The Golden Hills of Marin*. Displayed for 20 years in the assembly hall, it is now being restored, thanks to the Tam's Art Restoration Committee fund drive, hopefully in time to celebrate the high school's upcoming centennial in 2008. (Courtesy Trillium Press.)

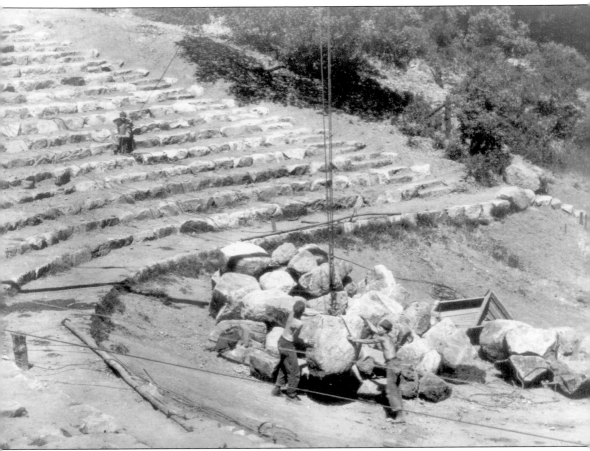

UP ON THE MOUNTAIN. The Civilian Conservation Corps transformed the site of the Mountain Theater by creating rows of stones that served both as seats and as risers between the aisles. Without any power, the crew moved thousands of stone blocks from the quarry site on another side of the mountain. According to author Lincoln Farley, the crew used 10- to 15-foot tripods and derricks to set the 600- to 4,000-pound rocks into rows 300 feet long. Each huge stone was buried so deeply that only a small part of it remained visible. The remarkable project was completed in 1940. Although the Mountain Play continued through the Depression years, the Dipsea race was not run in 1932 and 1933. The Gardner Fire lookout was also built in the mid-1930s by these workers, who camped, lived, and labored on the mountain. (Courtesy MVLHR.)

MILL VALLEY TRANSFORMS. While a brand new post office was built at Sunnyside and East Blithedale Avenues, and Miller and Blithedale Avenues were widened for better traffic flow, Mill Valley's beloved Summit School was razed. These young ladies holding court at the corner of Throckmorton Avenue and Old Mill Street were among the last to attend the old school, visible on the hill behind them to the left. (Courtesy MVLHR.)

KEYSTONE BUILDING. The 1906 building was remodeled in 1934 into a brand new Tudor-style building that gave the center of town a more elegant cachet. The mountain train's route, to the east of the building, had by then been closed off, and the Rutherford Drugstore now stood where the alleyway used to be. (Courtesy Jim Staley.)

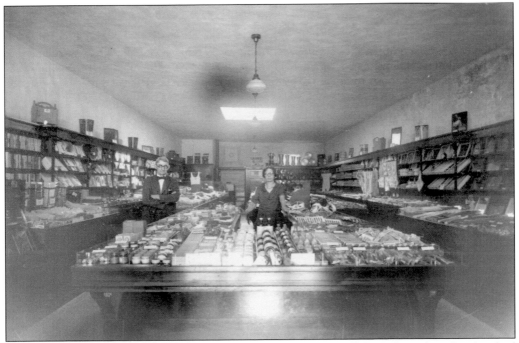

DIME STORES. Low-priced 5¢ and 10¢ stores were popular during the 1930s, when families had less money to spend. Joe and Dollie Baum kept a "five and dime" at 149 Throckmorton Avenue that remained at the same location for many years. (Courtesy MVLHR.)

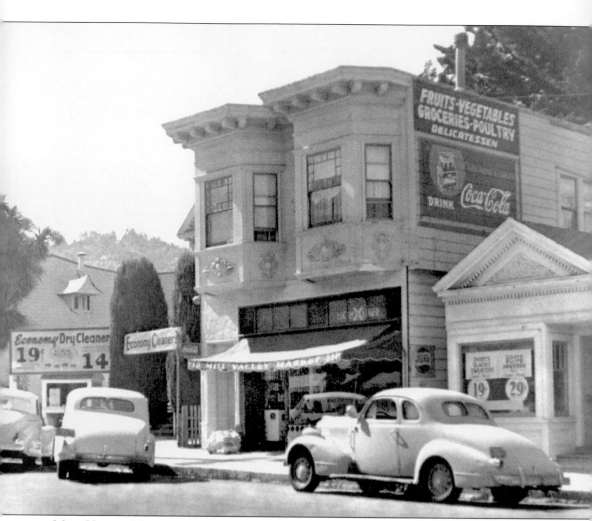

MILL VALLEY MARKET. A "Mill Valley Market" was first advertised in the local newspaper of April 1904. By 1923, the store was run by the Gosser family, until Frank Canepa, a native of Genoa, Italy, took over in July of 1929. The morning he reached the train station to open his store, all of Mill Valley was covered with smoke. Canepa was immediately recruited to fight the fire that was threatening the very center of town. The store moved to its present location in 1955, when Joe Morello became a partner. Two generations of Canepas still run the market that is the lone survivor of the seven grocery stores that used to exist in Mill Valley in the 1940s. (Courtesy MVLHR.)

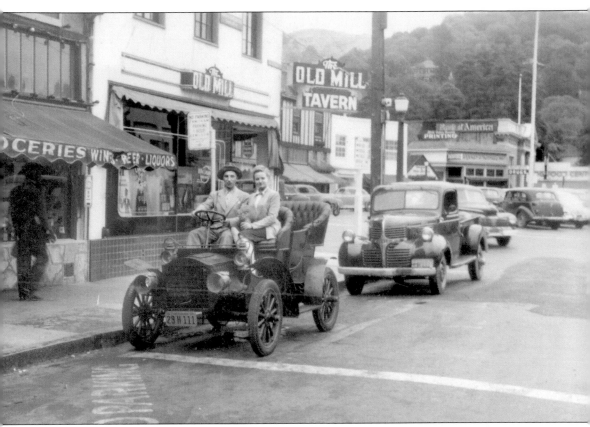

A POPULAR CORNER. Automobile styles changed as fast as business locations in the 1930s. Starting in 1929, the busy corner at Throckmorton Avenue and Bernard Street was occupied by Mill Valley's earliest Safeway store, one of a chain of neighborhood groceries born in Los Angeles before World War I. Late in 1938, when Safeway moved to the intersection of Sunnyside and East Blithedale Avenues, replacing the Costa Creamery, the popular Old Mill Tavern took over this popular corner. (Courtesy MVLHR.)

EL PASEO. Running counter to architectural fashion of the day, the new owners of the Holtum Building, Edna and Henry Foster, chose to remodel it in a Spanish Mission style created for them by contractor Gus Costigan. The garden chairperson of the Outdoor Art Club, Edna spared no effort to beautify the "ugly old building." When they acquired a lot behind it that fronted Sunnyside Avenue, a complex of buildings, courts, and gardens linking the two streets emerged naturally. (Courtesy Jim Staley.)

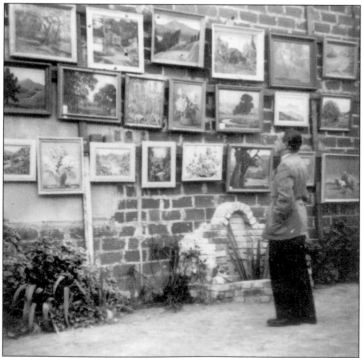

OLD-WORLD OASIS. The passageway that winds through the block to Sunnyside Avenue was made with old adobe bricks from Mexico, beams from razed Fort Cronkite, railroad ties from the mountain railroad, and wrought iron and tiles salvaged from the Guatemalan exhibit at San Francisco's 1939 World's Fair on Treasure Island. Doors were copied from old mission gates. Edna Foster's vision of a place where artists and craftsmen would live, work, and display their creations came to life in 1941. (Courtesy MVLHR.)

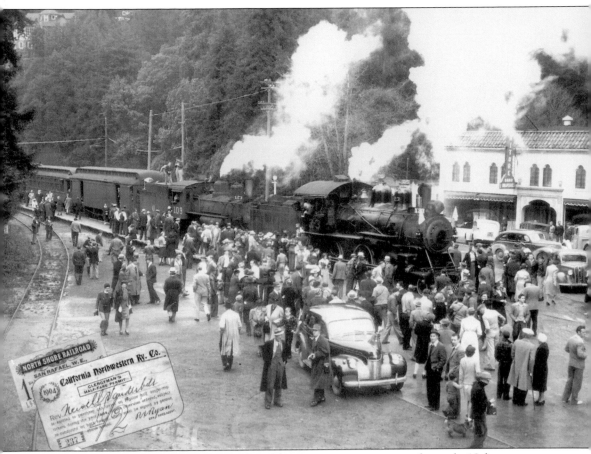

THE END OF COMMUTER TRAINS. Railroad losses were mounting in the early 19th century due to the proliferation of private cars. The Mount Tamalpais and Muir Woods Scenic train had closed in 1930. By 1940, it was the Northwestern Pacific Railroad's turn, as it was dealt a great blow when the Golden Gate Bridge opened in 1937. The end of passenger service on the Almonte-Mill Valley branch of the railroad had come. The last Northwestern Pacific passenger ferry from Sausalito to San Francisco ran in May of 1941. A *Mill Valley Record* editorial expressed a general sense of the end of an era on this occasion: "We regret the passing of the trains and ferries. They brought Marin a rare charm that it will never forget. Yet we have to hail the faster future with high hopes—knowing that the past and the future must always differ." The photograph above shows a rare steam excursion train that rumbled into Mill Valley sometime in the 1940s. (Courtesy MVLHR.)

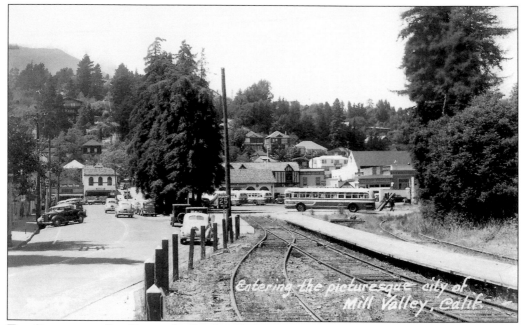

THE GREYHOUND BUS DEPOT. By October 1940, passenger trains stopped running and Greyhound buses took over, although the Northwestern Pacific continued to use the Miller Avenue right-of-way for freight service until 1955. At that time, the railroad tracks were paved over or removed, and Sunnyside Avenue was extended to Miller Avenue. All freight trains from Sausalito to Greenbrae stopped in November 1971. (Courtesy Jim Staley.)

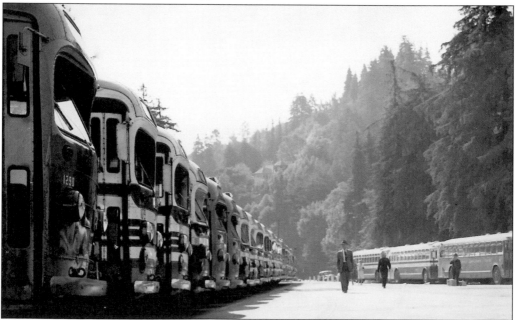

GREYHOUND PARADE. As time rolled on, automobiles and greyhounds became as familiar as the train tracks and trains stations used to be. The old depot remained the only substantial reminder of the railroads in Mill Valley's past, besides the memories many still hold dear. (Courtesy MVLHR.)

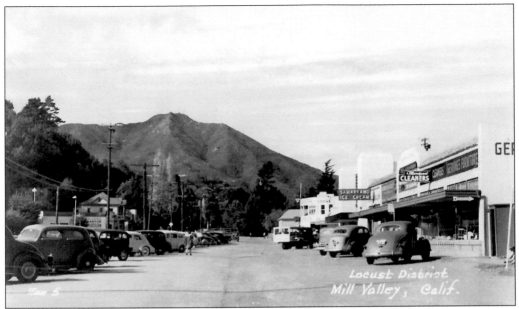

THE LOCUST DISTRICT. The increasing use of private automobiles made it much easier to reach outlying parts of town. The Locust district was the first commercial area to develop outside the town center, beginning in the early 1930s. (Courtesy Jim Staley.)

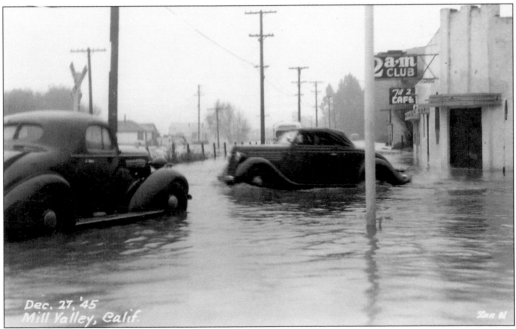

THE BROWN JUG. With the repeal of Prohibition, saloons reappeared, as did city-enforced midnight curfews and expensive licenses. In 1933, Joe Hormsby opened The Brown Jug at the corner of Montford and Miller Avenues. Located just seven yards outside the city limits, the bar observed the more liberal county curfew, hence its new name, The 2 a.m. Club. The 1945 flood of the Locust area, shown here, reminded everyone that the marsh was once navigable up to today's Montford Avenue. (Courtesy MVLHR.)

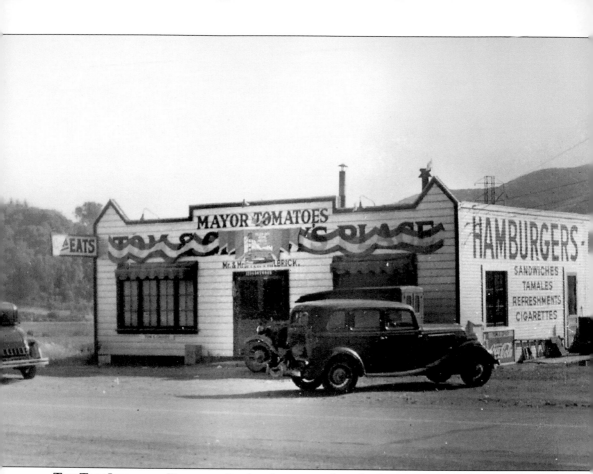

THE TAM JUNCTION DISTRICT. Further from town than the Locust area, another small business district developed around the former train junction known to this day as Tam Junction. Besides a cleaners, a gas station, and an inn, one of the Junction's earliest establishments was Thomas and Chrissy Philibrick's Mayor Tomatoes, a name that referred to Thomas's self-proclaimed status as "mayor" of Tamalpais Valley. According to Tamalpais Valley historian Bud Owen, Thomas campaigned energetically on behalf of an emerging Mill Valley between 1929 and 1934. He achieved many improvements, including the paving of Tam Valley Road, obtaining mail delivery, installing better water mains, and providing better school bus routes. Thomas and Chrissy operated their popular roadside stop until 1942, when Thomas left to help rebuild Pearl Harbor, joining the Navy for his second war service. By 1945, he returned to Tam Valley where he spent the rest of his days. (Courtesy Bud Owen.)

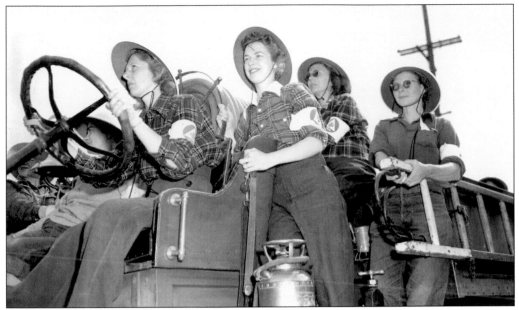

WAR TIME. The bombing of Pearl Harbor in 1941 drew the United States into war. Hundreds of Mill Valley men served overseas. On their own, women coped with blackouts and the rationing of food, clothing, and gasoline. They collected tin, took cooking fat to butchers for explosives, canned vegetables, and prepared packages for soldiers. Mill Valley Women's Civil Defense Corps included, from left to right, Mrs. Lloyd Arrowsmith, Evelyn Moitoza (at the wheel), Elinor Reiter, Mrs. Carl Englehart, and Eve Hooper. (Courtesy MVLHR.)

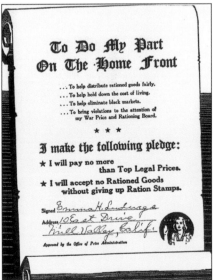

THE HOME FRONT. The war brought with it a whole new set of rules: long drives and long-distance calls were discouraged, there was a $25 fine for blackout violations when the sirens went off, the entire upper half of Mount Tamalpais was closed to the public, and the Tavern of Tamalpais was used as a barracks. World War I nurse Cornelia Ripley Sherman organized the Women's Fire-Fighting Team, training here under the supervision of fire chief Leslie Armager and assistant fire chief James Mathews. (Courtesy MVLHR.)

STATIONED ON THE MOUNTAIN. The Muir Beach Tavern, pictured here in August 1942, was a great off-duty place for the soldiers that manned the various observation posts, anti-aircraft gun emplacements, and base-end stations on the mountain. Pvts. Monroe Seaback, Toots Young, and Teddy Schmaltz are photographed here with Kathleen O'Brien and her horse Roxie, who was also known to occasionally frequent the bar. (Courtesy Robert Bolger.)

MUIR BEACH HOUSING. Even the little summer cabins at Muir Beach were used to house workers and soldiers brought to California by the war. The O'Briens had Coast Guard sailors living in the basement of their house, while infantry soldiers were stationed by Muir Creek. Kathleen O'Brien, daughter of "Doc" O'Brien, who ran the Muir Beach Tavern for decades, was in her teens when this picture was taken. The girl on the left is her friend Rosemary. (Courtesy Robert Bolger.)

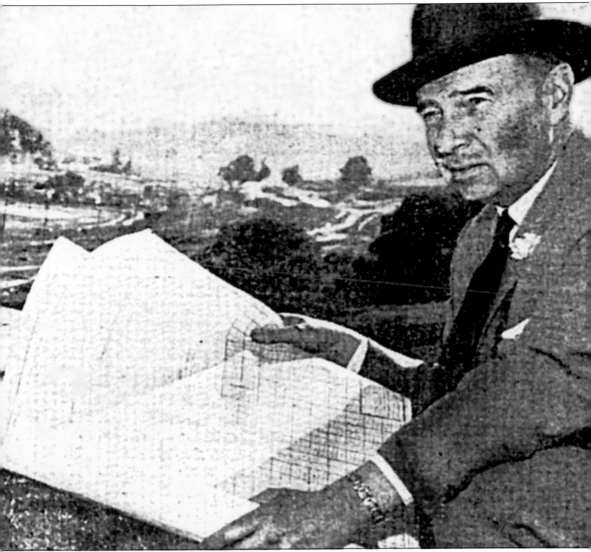

DEFENSE HOMES. Thousands of workers from other states flocked to Sausalito's Marinship, the huge shipyards that supplied the war effort with Liberty Ships intended to ferry soldiers and material to Europe. These men and their families flooded Marin County looking for scarce housing. Scores of new "defense homes" were built, a designation indicating that developers had preferred priorities on materials. The most prominent of these developers was George Goheen, whose initial office was located in a converted hot dog stand at 125 Camino Alto, "right across a pig farm and a garbage dump," as he recalled. He ended up building almost 100 homes in Alto and in Strawberry, and on the marshland between Sycamore Avenue, Miller Avenue, and Camino Alto, soon nicknamed Goheen Gulch. (Courtesy MVLHR.)

TAM HIGH'S MEMORIAL CLOCK. News of Japan's surrender triggered a day of exuberant celebration in Mill Valley. The air raid sirens on the Sequoia Theater's roof wailed, cars drove about honking, and rejoicing residents poured into the streets. But all liquor venues closed down, respecting the soberness of the occasion. Many Mill Valley men would not return, among them 40 former Tam High students. In 1946, a memorial clock was added to the school's Wood Hall tower in their memory. (Courtesy MVLHR.)

PEACE TIME. Men who returned found changes in their hometown. After serving for "four years, six months and eleven days," Frank Dittle discovered he could not hunt quail and deer in the newly developed Homestead Valley. Trains were gone, and the marsh was being filled at the edge of Camino Alto. Pictured from left to right, Bob Sempell, Angie Rometti, and Joe King salute the war dead at the World War II memorial rock in front of city hall. (Courtesy MVLHR.)

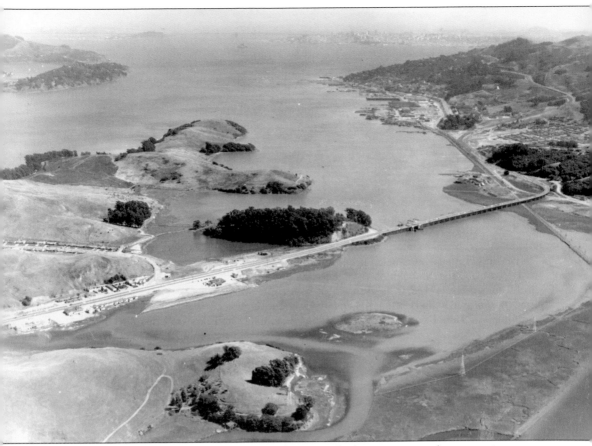

STRAWBERRY POINT. Following Japan's surrender in 1945, the international community came together in San Francisco and signed the charter that established the United Nations. Mill Valley's Strawberry area was one site considered for the United Nations' headquarters, with a proposed 10-building complex in an architectural style similar to Frank Lloyd Wright's Marin Civic Center. This plan was superseded by the Rockefeller offer in Manhattan. Modern development of Strawberry began in 1947. (Courtesy MVLHR.)

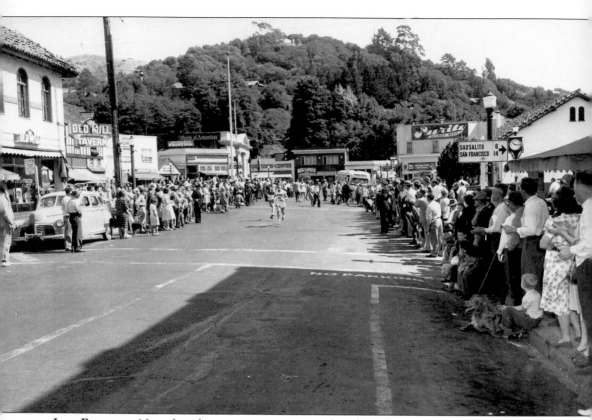

LIFE RESUMES. Now that the mountain was opened to the public, the Mountain Play resumed, and so did the Dipsea Race, with 38 runners signed up for its 1946 comeback. Wartime price controls remained in place, electricity was still rationed, steel, sugar, and meat were in short supply, and Easter egg hunts had to be cancelled due to an egg shortage. January 1, 1948, was the first day of city mail delivery for Alto, Almonte, Homestead, Tamalpais Valley, and Marin Heights. Their mail now had to carry a street and house number, since the post office department now considered them a part of Mill Valley. (Courtesy MVLHR.)

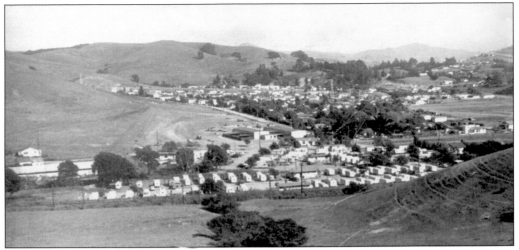

POSTWAR BOOM. With peace came many delayed weddings, war brides, and a baby boom. Scores of Marinship workers did not go home. Mill Valley's population doubled, from 5,000 in 1941 to 10,000 in 1950. Low-cost defense housing continued to multiply at Strawberry Point and Tam Valley, Sycamore, and Alto, pictured above. George Goheen's companies built 426 homes in Mill Valley and Alto between 1937 and 1950. Half of all Mill Valley residents lived in a Goheen home by 1950. (Courtesy MVLHR.)

EDNA MAGUIRE. The baby boom created record school enrollment, with classes of 48 students. Alto School opened in 1947, named for Sarah Edna Maguire, born in Nevada City's gold rush country, where her father was superintendent of a hydraulic mine. Maguire, who came to Mill Valley in 1920 as principal of Homestead School, recalled that many adults worked around the clock during the war, dropping their children off at 7:00 a.m. and not picking them up until 7:00 p.m. (Courtesy MVLHR.)

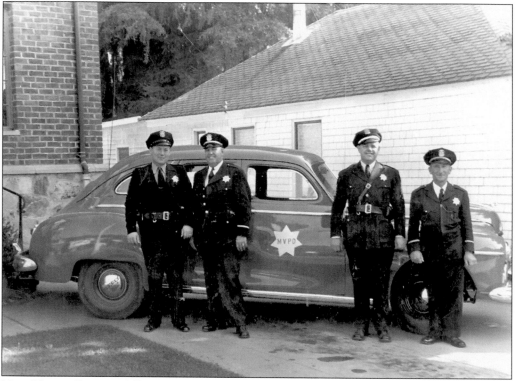

MILL VALLEY POLICE. Officers were quite busy after the war dealing with holdups, poisoned dogs, and delinquents but also with new traffic issues. Drunk driving accounted for 60 percent of all accidents. The city resorted to such innovations as "automatic stop and go signals" to regulate traffic flow and a sort of blood test called a "drunk-o-meter." This *c.* 1947 photograph shows, from left to right, Mill Valley officers Lee Sellers, Chief McGowan, Charles McCourtney, and Joe Canet. (Courtesy MVLHR.)

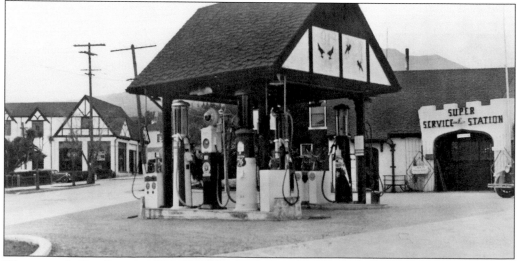

WESTLEDER'S GAS STATION. Ken Westleder remembered that he had to teach his customers how to drive before he could sell them a new car. His Studebaker dealership at 103 East Blithedale Avenue doubled as a service station where he sold several brands of gasoline. (Courtesy MVLHR.)

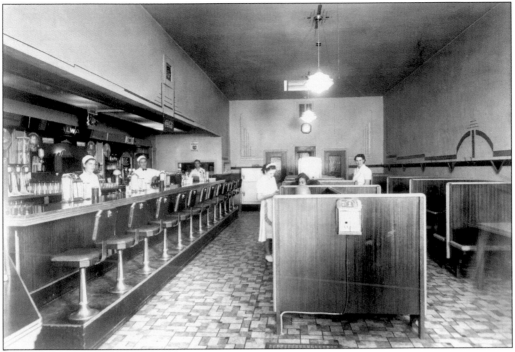

HERALDING THE 1950S. In 1914, the Esposti's candy shop and soda fountain opened at 127 Throckmorton Avenue. The popular store was operated by Delemo and Ettore Esposti, brothers who had moved to Mill Valley from their native town of Bologna, Italy. In 1936, they remodeled the interior of their store to accommodate a restaurant where they offered breakfast, lunch, and dinner. By 1964, Sal and Maria Aversa took over the establishment, opening La Ginestra with the same interior layout. (Courtesy MVLHR.)

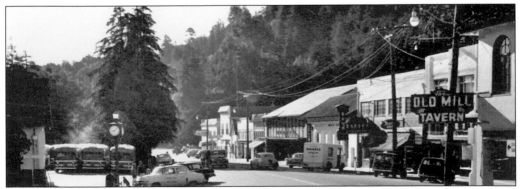

MODERN DAYS. The end of the 1940s heralded Mill Valley's modern era, with the first television—at The 2 a.m. Club—dial telephones, Polaroid cameras, Studebakers, and unfortunately, with polio as well. There were 36 recorded polio cases in Mill Valley in 1948. This late 1940s view looking south from the Throckmorton at Miller intersection, shows how Mill Valley was now a "bus" town, with cabs and greyhounds near the Depot. A Wonderbread truck parked on the right-hand side encapsulates the upcoming decade. (Courtesy MVLHR.)

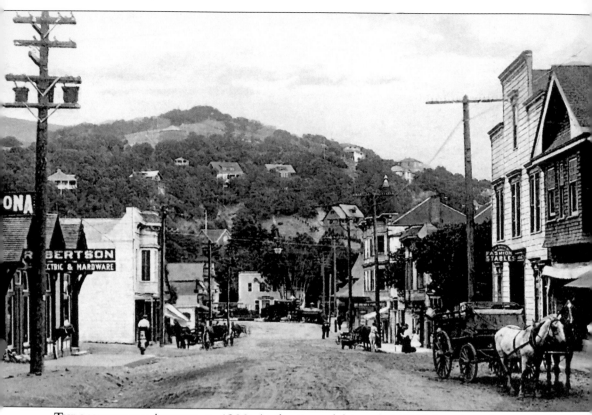

THROCKMORTON AVENUE, C. 1900. At the time of this early Mill Valley view, the population did not exceed 900. The top of the hill at the bottom of Throckmorton Avenue is denuded, with only a few housetops showing. There is a heavily wooded area at the base of the hill, right behind the buildings at the end of the street, as well as islands of trees within the blocks of buildings. The street is unpaved, with horse-drawn carriages reigning supreme, and plenty of livery stables, like Dowd's Fashion Stables on the right hand side. The scenic train appears at the end of the street, crossing what would become Lytton Square, to start its ascent up Mount Tamalpais. There is electricity, but only board sidewalks. (Courtesy Jim Staley.)

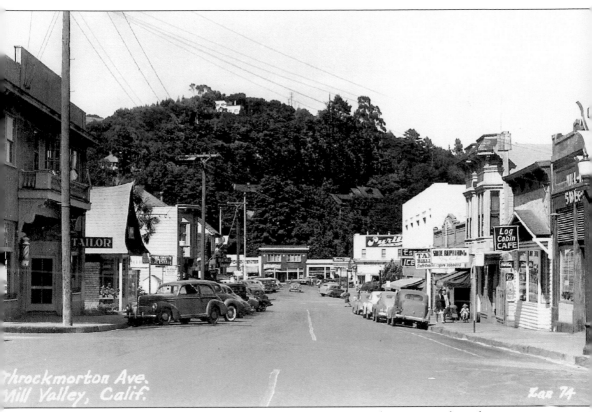

THROCKMORTON AVENUE, 1950. Mill Valley was now a town of 10,000 people and it presents a much different aspect. The hill at the bottom of the street is more heavily forested, hiding homes and yards, and a few eucalyptus trees are now peaking from the mass. The streets are paved, sidewalks are extending into the street. While several old buildings survived, there are no more groves of trees on the block, and the mountain train has vanished, superseded like the livery stables by the ubiquitous automobile. (Courtesy Jim Staley.)

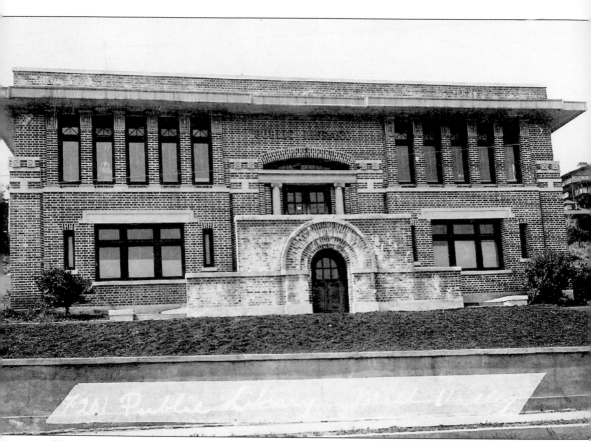

NEIGHBORHOOD TALES. This photograph shows the Mill Valley Library as it looked in its previous life as a brick neoclassical building erected with a grant from the Andrew Carnegie in 1911 at 52 Lovell Avenue. Its research library was an American bicentennial project, named for Lucretia Hanson Little, a 1925 Summit School graduate and the city's unofficial historian, who donated her collection to help start it in 1976. The History Room's treasures include a Miwok mortar and pestle found in one of the town's middens, albumen photographs of the Reed family, scenic train and Dipsea memorabilia, and Ludmilla Welch's Mount Tamalpais paintings, besides an excellent collection of old photographs that will soon be preserved in digital form. Transcripts of interviews with over 100 longtime Mill Valley residents, historic house and building files that contain individual folders about the city's landmarks and homes, and microfilmed copies of local newspapers from 1907 to the present provide glimpses of the events that shaped the community. The shelves contain books by past authors who have had a significant association with the city, like Kathleen Norris, Jack London, and Jack Kerouac, and recent local authors' works like Barry Spitz's excellent *Mill Valley, the Early Years*, a must-have reference book on the city's early years; Lincoln Farley's *Mount Tamalpais, a History*; and Ted Wurm and Al Graves's *The Crookedest Railroad in the World*. (Courtesy Jim Staley.)